THE {creative} ENTREPRENEUR

QUARRY

ARE YOU
READY?

ARE YOU EVER?

THIS IS GOING
TO BE
HEAVY

BEND YOUR KNEES....

THE {creative} ENTREPRENEUR

A DIY Visual Guidebook for Making Business Ideas Real

QUARRY BOOKS

Lisa Sonora Beam

First published in the United States of America by
Quarry Books, a member of
Quayside Publishing Group
100 Cummings Center
Suite 406-L
Beverly, Massachusetts 01915-6101
Telephone: (978) 282-9590
Fax: (978) 283-2742
www.quarrybooks.com

Library of Congress Cataloging-in-Publication Data

Beam, Lisa Sonora.
 The creative entrepreneur : a DIY visual guidebook for making business ideas real /
Lisa Sonora Beam.
 p. cm.
 ISBN 978-1-59253-459-3
 1. Creative ability in business. 2. Entrepreneurship. 3. Small business—Management. 4.
Artisans. I. Title.
 HD53.B426 2008
 658.1'1—dc22

 2008015681

ISBN-13: 978-1-59253-459-3
ISBN-10: 1-59253-459-7

10 9 8 7 6 5 4 3 2 1

Design: Laura H. Couallier, Laura Herrmann Design
Cover Artwork: Lisa Sonora Beam

Printed in China

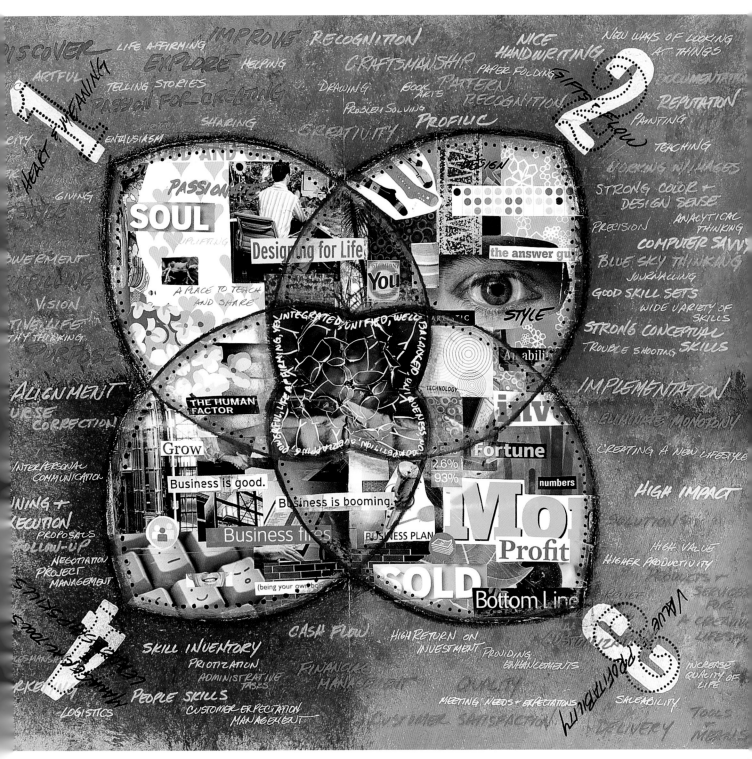

Andrew Borloz

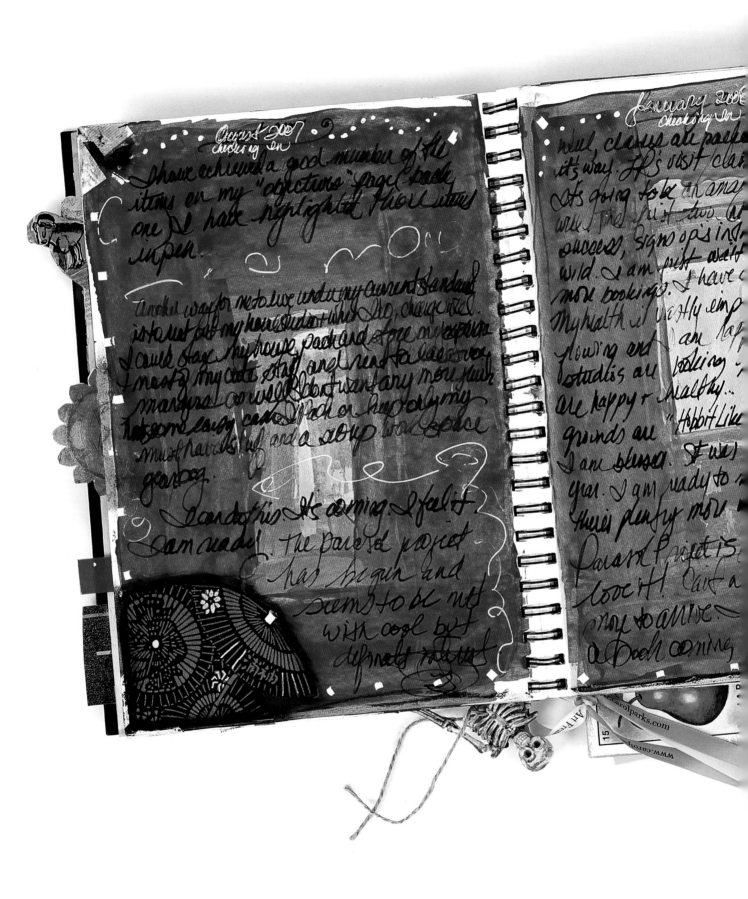

Contents

Carol C. Parks

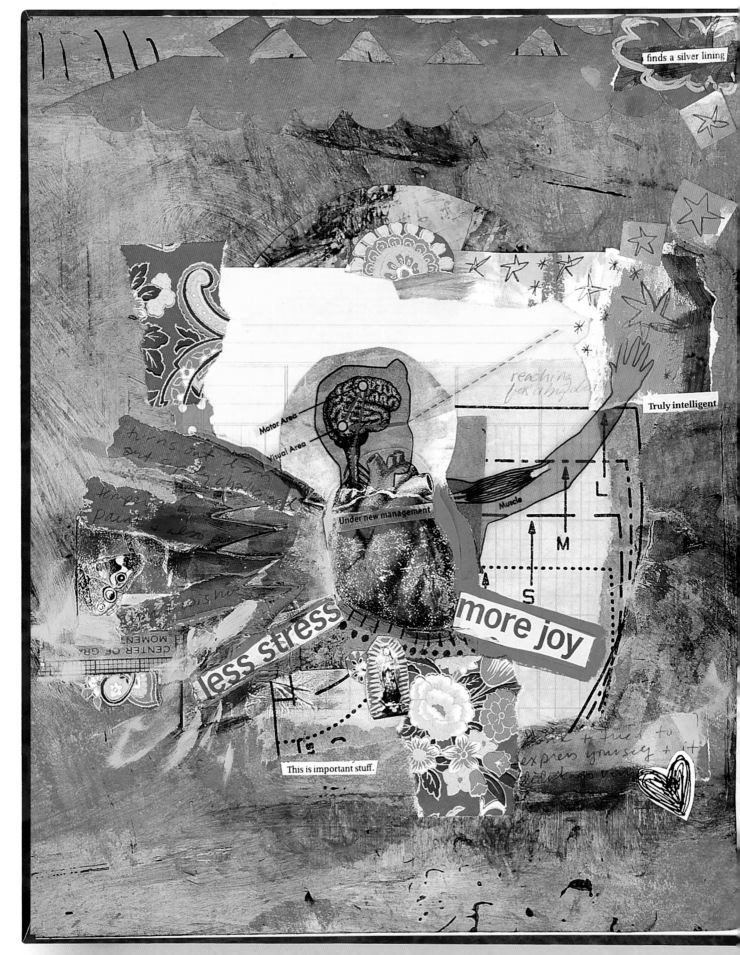

Introduction

The Creative Entrepreneur

is based on workshops designed to meet the challenges creative people have with the business side of their work. These are the people who experience a kind of mythic divide between their creative work and the necessary evil of business must-dos. This split can create tension and even trauma for the creative soul who is blessed with passion and purpose yet cursed by the seemingly mysterious realm of strategies and skills that are necessary to make an idea real.

For those who have achieved success in one area, it may seem like luck or good timing. What they did before may or may not work this time, not because of their effort but because of the changing, dynamic nature of the marketplace.

What is lacking is an approach to thinking about (and acting on) business ideas that considers how creative types think, feel, and work. Most other books on developing

A Disclaimer:

Throughout this book, I use the term *creative* to describe the person inclined to do work that is their own expression. I believe everyone has creative gifts, but what I mean here is the creatively oriented personality.

a successful business focus on a selection of tactics that addresses outer solutions (such as setting goals, writing a business plan—ugh!—setting aside time for marketing, and hiring a rep). But without addressing the underlying issues that cause creatives to remain business-challenged, no amount of goal setting or knowledge of savvy business tactics will help. *The Creative Entrepreneur* addresses the three main issues that can result in creative business failure: emotional and psychological blockages, faulty thinking about the creative process, and a lack of practical business knowledge.

Lisa Sonora Beam

Why a Visual Journal Process?

Creatives tend to be visual, action-oriented learners. We respond to visual stimuli. We also need to be engaged in a personal, meaningful way with the material. We don't learn well through abstractions. For the past twenty years, I have taught visual journaling as a powerful way to develop problem-solving abilities and gain insights in ways that linear, nonvisual approaches to thinking and learning don't access. Visual journaling helps us go beyond what we know in our rational mind, so we can access other ways of knowing—the kind of knowing that results in truly original thinking, ideas, and creative breakthroughs.

This book is neither a touchy-feely self-help guide nor a technical dump of business concepts. Each topic is presented to engage both the heart and mind while teaching practical action steps that can be taken now, whatever your level of experience.

This book is designed as a do-it-yourself reference guide and toolbox meant to be used in an ongoing and as-needed way. You'll find powerful business and leadership tools (some little known or used except by the most skilled managers) that can be put to use at once, whether the problem is a result of an inner creative block or a simple lack of technical knowledge.

The processes shared in *The Creative Entrepreneur* can be accessed by all, but the specifics of each are as unique as the individual. That's why a cookie-cutter approach to succeeding in business so rarely works. The beauty of the process described here is that you are using proven tools to create your very own road map for getting from where you are right now to where you want to be. Where and how you travel will look very different from other people's paths.

I look forward to guiding you step by step through what I consider one of life's most courageous and meaningful endeavors: manifesting the creative work only you can do.

—LISA SONORA BEAM

Thriving, Not Surviving

My creative dream has always been to be a thriving artist doing meaningful work that makes a difference. Realizing that dream involved a lot of trial and error. What kept me going (aside from sheer stubbornness) were two drivers: 1. not wanting to be a starving artist; and 2. being able to do meaningful work that fully utilized my creative abilities in ways that also empowered others. The work presented in *The Creative Entrepreneur* has its roots in seemingly divergent areas of my work and life: psychotherapy, business, spiritual practice, creativity consulting, teaching, and being a lifelong artist in several media including music, visual art, and writing. The illustrations in the book come from participants who have done the exercises in *The Creative Entrepreneur* workshops. These workshops came about simply because others kept asking me to show them what I knew about creativity and business. I love teaching as much as I do making art and pursuing entrepreneurial endeavors, so I dove in and began road testing and refining the material. If I were to encapsulate my mission, it would be: No more starving artists! My wish for you is that you take this material and use it, and that it helps you thrive beyond your wildest imaginings.

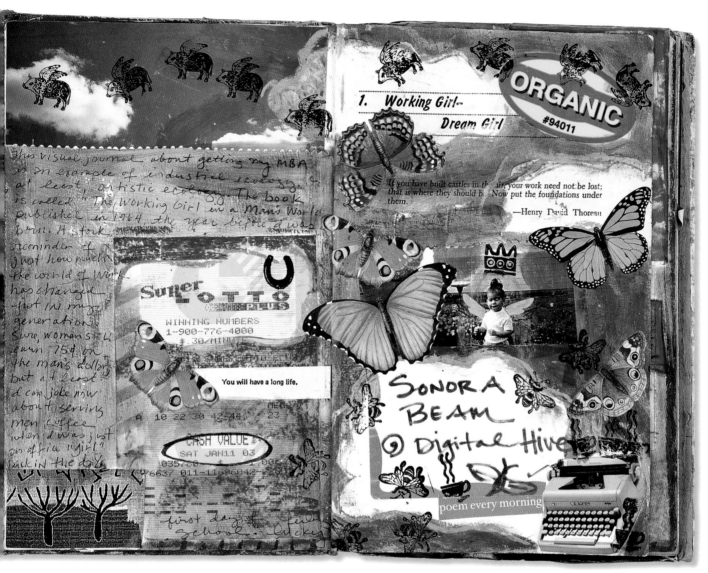

The author's own journal, created by altering the 1964 book *The Working Girl in a Man's World*. The journal was begun at the start of an MBA program. Because the undertaking seemed as probable as pigs flying, the book is filled with that rubber-stamped image, along with childhood photographs. The themes of destiny and the mythic journey are considered along with the trials of being an artist in business school.

Lisa Sonora Beam

"The soul speaks in image."

—Carl Jung

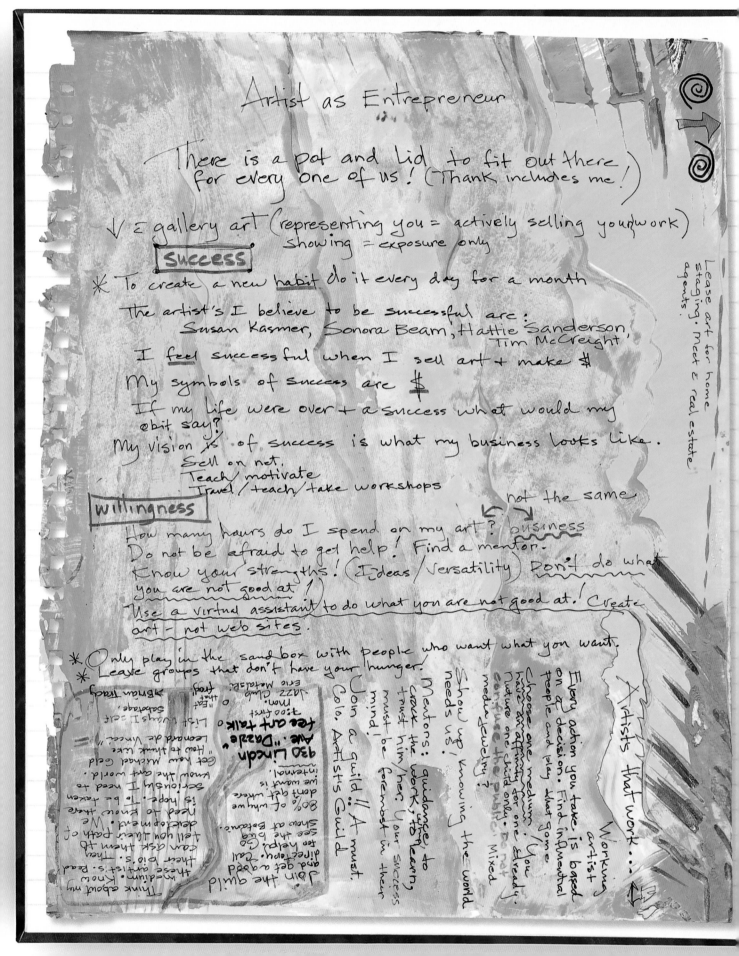

Artist as Entrepreneur

There is a pot and lid to fit out there
for every one of us! (Thank includes me!)

√ ≥ gallery art (representing you = actively selling your work)
showing = exposure only

Success

✳ To create a new habit do it every day for a month

The artist's I believe to be successful are:
Susan Kasmer, Sonora Beam, Hattie Sanderson,
Tim McCreight.

I feel successful when I sell art + make $

My symbols of success are $

If my life were over + a success what would my
obit say?

My vision is of success is what my business looks like.
Sell on net.
Teach/ motivate
Travel / teach / take workshops

willingness

not the same

How many hours do I spend on my art? business
Do not be afraid to get help! Find a mentor.
Know your strengths! (Ideas / Versatility) Don't do what
you are not good at!
Use a virtual assistant to do what you are not good at! Create
art - not web sites.

✳ Only play in the sandbox with people who want what you want.
✳ Leave groups that don't have your hunger!

Think about my
medium. Know
these artist's. Read
their bio's. They
can ask them to
tell you their path of
development. We
need to know these
seriously I need to
"How to think like
Leonard de Vinci"
Get how Michael Gold
know the art world.
List things I self
sabotage.
Eric Motose!
Brian Tracy

930 Lincoln
Ave. "Dazzle"
tea art talk o
1:00 first
Jazz Club
o "Eat
that frog"

80% of why we
don't get where
we want is
internal.

Join the guild
and get a good
direction. Call
for help. Go
see the big
show at Betona.

Join
a guild!! A must.
Colo. Artist's Guild

Mentors:
crack the work; to learn,
trust him/her. Your success
must be foremost in their
mind!

Show up knowing the world
needs us!

Every action you take is based
on a decision. Find influential
people and play what some

Choose one medium. You
have imagination for one already;
nurture one child only. Don't
compose the public. Mixed
media Jewelry?

Artists that work....

Working
artist

Lease art for home
staging. Meet & real estate
agents.

Setting Up Your Visual Journal

1

Visual journaling is one of the most powerful tools I know to gain insight, solve problems, and explore new ideas without the pressure to produce a product or something that has to look good or make sense to others. This section begins by discussing some of the traits of visual journaling that make it an appealing and unique vehicle for these entrepreneurial explorations. I also suggest some simple supplies to gather before you get started.

What you create in your visual journal may end up being artistic—or not. It doesn't matter. The ultimate work of art is *you* and the ideas you are bringing to life. It's the intention behind your process that is important. If you have trouble with the word *journal,* call it a sketchbook or a notebook. Sketches and notes are never confused with the work they ultimately inspire.

Why Visual Journaling?

Economy

Visual journaling is an economical craft, in cost as well as scale. No fancy art materials are necessary. There's no big investment—perhaps no investment at all—in supplies. Most of the required materials you probably have on hand or can purchase from the drugstore or office supply store. Limits are important to the creative process. This may seem counterintuitive, but having an unlimited array of supplies can actually have a paralyzing effect: When we have infinite choices, we have a hard time choosing anything at all. What sorts of limits might you experiment with now, as a creative challenge?

Accessibility

Anyone can make a visual journal. No prior visual art or writing experience is required. There is no right or wrong way to make a visual journal. Even when several group members are working with the same supplies and form of book, their results are as unique as the individual. The most important requirements are being willing to experiment, to question, and to enter into a space of not knowing so something new can emerge.

Privacy

A visual journal is a journal, first and always. It's meant to be sacred, private space. Treat it as you would a written diary.

Process, Not Product

When we make "art," we feel compelled to share it, sell it, or do something meaningful with it. Those who gain the most from the visual journal process are able to separate process and product. They are able to think of and use their visual journal as a container for their inner process rather than treat it as a work of art.

Portability

A visual journal and its associated supplies are easy to take with you or have at the ready whenever you want to work. This makes it easier to stay involved in the process, a key for achieving the intended results over time.

Style

Blank hardbound or wirebound sketchbooks are inexpensive and versatile. It's easy to modify them by painting backgrounds and removing or adding pages. Best of all, you have a blank slate where you can start working immediately; no advance preparation is necessary. If you have trouble starting projects or get hung up searching for the perfect book to work in, start with a plain blank book.

You can recycle an existing book into your visual journal or make your own journal book. Just be aware of time spent crafting the perfect journal at the expense of *working* in it.

Supplies

Ballpoint pens are good for doing the writing exercises. If painted over, the ink won't smear. Certain pencils work without smearing, too. Just test them first. Look for pens or markers that write over painted surfaces. Be sure the surface is dry before writing or else the pen will gum up.

Get a small supply of inexpensive craft paints, whatever brand is available at your local craft or department store. Use acrylic or tempera paints that dry quickly, making it easy to layer colors and then write on top of them. Watered-down cheap white paint is a great way to transparently cover background collage material.

Before you shop for supplies, check to see what you already have. Crayons and markers, watercolor sets, tape, colorful stickers, tissue paper, wrapping paper, and greeting cards are all fodder for the imagination and your journal. The children's versions of all of these supplies are just fine for visual journaling.

You'll also want to start collecting ephemera—the flotsam of daily life—receipts, photos, notes, junk mail, to-do lists. These can all be great additions to your journal. They provide the background narrative of your thoughts and your days. For other background elements, try using stuff from your old work: drawings, plans, paint chips, torn-up sketches, edited manuscripts, project notes, calendars, brochures, and contact lists.

Artistic Act of Generosity

If you have professional-quality art supplies you've been saving to make something "important" with, then by all means, gather them up and dare to use them abundantly in your visual journal. There is a certain satisfaction about using really good supplies on process work that no one else may ever see. This act also sends a message to the subconscious mind that you are serious about the work you are doing in your journal.

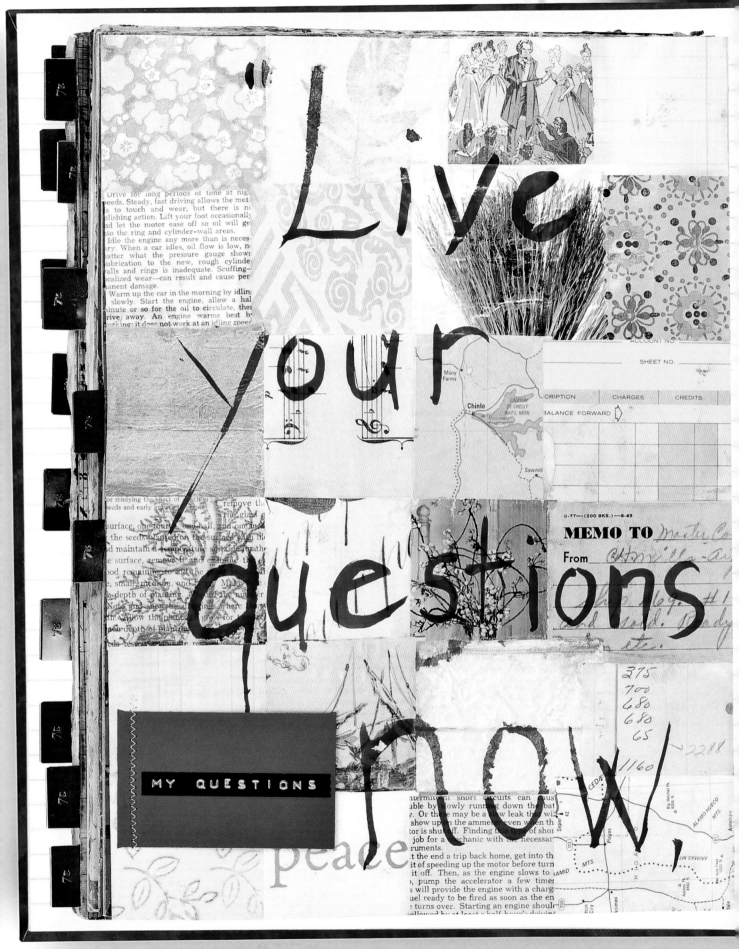

Empowered to Flower:
The Creative Entrepreneur Mandala

2

Jennifer Joanou

IN MY FIRST ADVISING SESSION IN BUSINESS school, I was asked, "What is the unique gift you can leverage that has a value in the marketplace people will pay for?" That was a potent question that I lived with for a couple of years as I refined my business plan. While I was aware of some things I was good at, I didn't really think of them as "gifts." Even more radical was the idea of putting a dollar value on these so-called gifts. And if I could manage that daunting task, how could I possibly know what value people were looking for? Finally, would customers really pay me for that? If so, what else would be necessary to create a viable business out of these ideas? Considering those questions, and subsequently working with clients to answer those same questions for themselves, led me to design a model for creative business development that I call the Creative Entrepreneur Mandala.

"We are the only species on Earth
capable of preventing our own flowering."

—David Whyte

The Creative Entrepreneur Mandala consists of four pathways that will help you design a viable creative business.

Pathway 1: Heart and Meaning looks at how to follow your heart's desire and creative dreams, while lessening the potential for heartbreak.

Pathway 2: Gifts and Flow reveals how uncovering and using your unique gifts contributes to flow, or less-effortful accomplishment.

Pathway 3: Value and Profitability is about creating a customer-centric business, and how to create and deliver value that people will pay for.

Pathway 4: Tools and Skills presents the vital necessity of developing your business skills and leadership capacities (which few entrepreneurs are willing to do) to achieve the results you want in areas 1 through 3.

Each of these four essentials is looked at as an individual pathway that, when put together, form a mandala, or flower shape. The goal is to find the overlapping center of the four pathways, which represents the "sweet spot" of your business—the absolutely unique value you offer to the marketplace that is aligned with your innermost aspirations and ideals. The mandala provides a template for working with the four pathways of the business in a visual manner.

Awareness of and continual refinement of all four pathways is crucial for launching and sustaining the kind of enterprise that works for creative individuals. When even one pathway is missing, the outcome we get from our efforts is different—less—than if all four are used together. This process of refinement is meant to be continual, reflecting the dynamic nature of the marketplace and also the changing nature of our own goals and plans.

Don't be discouraged if "getting" all four pathways seems daunting at first. The mandala is a tool for reflection and critical thinking, which requires time and space to evolve. It is something to work with at regular strategic planning meetings, monthly, quarterly, and annually.

The word *mandala* is from Sanskrit, and is loosely translated as a "magic circle." The mandala appears cross-culturally as an archetypal symbol of wholeness and is a pattern that occurs in nature. Mandalas became a central theme in psychologist Carl Jung's work as a healing tool to aid in the process of *individuation* (becoming a whole person).

THE CREATIVE ENTREPRENEUR MANDALA

Lisa Sonora Beam

The Creative Entrepreneur Mandala consists of four intersecting pathways that form a flower shape. Arriving at the center "sweet spot" is the result of refining each pathway.

FLOW

SKILLS

PROFIT ABILITY

HEART

sweet spot

MEANING

VALUE

GIFTS

TOOLS

Exploring the Four Pathways of the Creative Entrepreneur Mandala

This section provides an overview of each pathway, with a series of questions to use as prompts for spontaneous writing in your journal. It is recommended that you complete pathways 1 and 2 first for yourself as an individual. Then complete an entire mandala of all four pathways for your business concept or new product or service idea. If you are new to business strategy, it will be easier to complete pathways 3 and 4 of the mandala after you have worked with the material in chapters 4 and 5.

JOURNALING TIP

How to Approach Writing in Your Journal

1. Write each prompt question in your journal. Simply writing in pen on blank paper will do. If you want to turn it into a more contemplative exercise, paint or stamp the questions using alphabet stamps. This process will slow you down and help you "live" the questions.

2. Set a timer for three minutes and respond to one question, keeping your pen moving as fast as possible, not editing or worrying about spelling or punctuation. Write directly into your journal or on separate sheets of paper. Add these pages to your journal in a pocket or envelope; you'll want to keep them for further reflection.

3. Repeat the three minutes of timed spontaneous writing for each question.

4. Let the writing sit for a few days or a week. Go back and circle key words or phrases that you want to explore more. Do timed writings for each circled word, adding to your journal.

5. If you wrote on blank pages, go back to the writing and add color and/or images. This is another way to expand on the insights and ideas that flowed from the writing.

"Every day when you wake up, ask yourself,
'What do I really, really, really want?' You have to say
really, really, really, otherwise you won't believe it."

—Elizabeth Gilbert

Pathway 1: Heart and Meaning

Creatives have a strong need for a sense of passion and purpose in their work. This is typified by those of us who work for joy or intrinsic value, regardless of how much money we make. Doing work that uses our talents and makes us happy is its own reward. Yet, if you are reading this book, you are probably wondering, "How can I do what I love *and* make money at it?"

Why Heart and Meaning Is Important

Without Heart and Meaning, it is extremely challenging for the creative soul to keep moving forward when business gets hard. Having big doses of passion and a burning sense of mission for your work will keep you on task, even when the going gets tough.

Why Heart and Meaning Alone Are Not Enough

Lots of career counselling and business coaching starts and ends with having you identify what you enjoy doing. But without considering whether what you enjoy fully uses your gifts and adds value in the marketplace, or helps you learn how to manage your business—all you might have is a heart that can easily be broken. That may sound

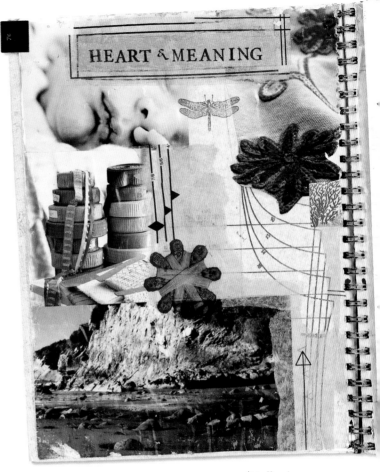

Jennifer Joanou

dramatic, but it actually takes very little to derail a creative pursuit, because it is work of the heart and soul. For those who already do the work they love, yet find the financial rewards lacking, the other three pathways will help to achieve alignment in this area.

[myth]

If you do what you love, the money will follow.

[reality]

Doing what you love is vital; that's why the first pathway addresses your heart's desire. Paradoxically, probably the quickest way to a broken heart is focusing on what has Heart and Meaning to the exclusion of other matters.

Exploring the Pathway of Heart and Meaning

- I've always wanted to:

- My creative dream is:

- What do you do for its intrinsic value—that is, what would you do even if it didn't pay?

- What matters most to you?

- What do you value?

- What are you most passionate about?

- What do you have a burning desire to do or accomplish in your life?

- If you were to answer your creative calling and knew you could not fail, what would you do?

- What does your deepest creative longing look like?

- What do you want to be doing more than anything else?

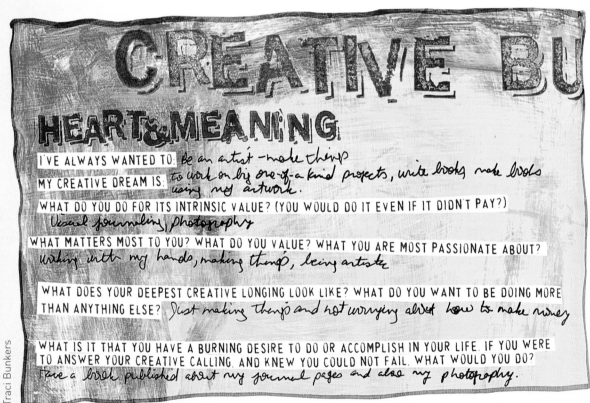

CREATIVE BU

HEART&MEANING

I'VE ALWAYS WANTED TO: *Be an artist - make things*

MY CREATIVE DREAM IS: *to work on big one-of-a-kind projects, write books, make books using my artwork.*

WHAT DO YOU DO FOR ITS INTRINSIC VALUE? (YOU WOULD DO IT EVEN IF IT DIDN'T PAY?) *Visual journaling, photography*

WHAT MATTERS MOST TO YOU? WHAT DO YOU VALUE? WHAT YOU ARE MOST PASSIONATE ABOUT? *Working with my hands, making things, being artistic*

WHAT DOES YOUR DEEPEST CREATIVE LONGING LOOK LIKE? WHAT DO YOU WANT TO BE DOING MORE THAN ANYTHING ELSE? *Just making things and not worrying about how to make money*

WHAT IS IT THAT YOU HAVE A BURNING DESIRE TO DO OR ACCOMPLISH IN YOUR LIFE. IF YOU WERE TO ANSWER YOUR CREATIVE CALLING, AND KNEW YOU COULD NOT FAIL, WHAT WOULD YOU DO? *Have a book published about my journal pages and also my photography.*

Traci Bunkers

Type out the journal prompts and write in your answers for a quick and easy way to get your ideas on the page.

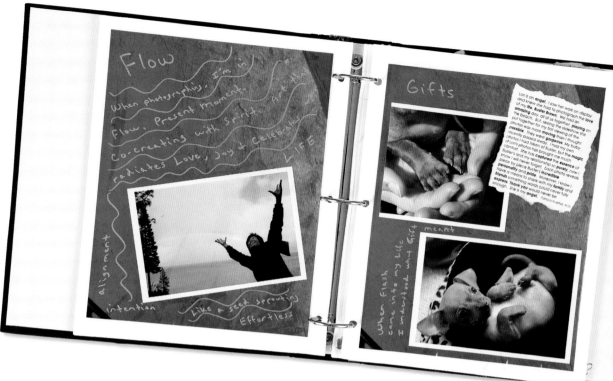

Photographer Lori Cheung's journal is housed in an old-fashioned photo album.

Lori Cheung

Pathway 2: Gifts and Flow

The pathway of Gifts and Flow asks you to consider what your unique gifts are and how using those gifts strengthens the value of your business. Everyone is gifted at something, usually many things. Using a gift doesn't mean we're not working hard. When we are engaged with our gift, it doesn't seem like there are more compelling alternatives. We're fully engaged with the effort. Flow is just what it sounds like: easy movement downstream, pulled by a current. Flow could also be called effortless accomplishment. When we're in the flow, we can be working our butts off but it doesn't feel hard. We don't feel as if we are rowing upstream.

Why Gifts and Flow Are Important

It takes tremendous courage to follow where your innate gifts lead, as that often means venturing into unfamiliar territory, forging a path that is wholly your own and not mapped out by someone else. Alignment with Gifts and Flow helps balance Heart and Meaning by deciding what *not* to be doing. This can provide a strategic advantage your competitors are probably not considering. It takes discipline to not try to be all things to all people. It seems counterintuitive, but the more you develop a specific niche or specialty, the easier it is to achieve your objective. When you let go of what you don't want to be doing (what isn't a gift or doesn't create flow), you create a space in which to do more of what you do want to be doing.

Why Gifts and Flow Alone Are Not Enough

Many excellent, talented people are frustrated by their lack of financial or market success. Talent alone rarely equals success, and success does not always correlate with the greatest talent. Gifts and Flow are enhanced when the other three pathways are engaged. This is the ultimate competition buster because many gifted people do not take care to develop their areas of weakness, nor do they deeply consider what their clients or customers want. Mastery of all four pathways has the effect of honing and polishing your gifts and creating even more flow.

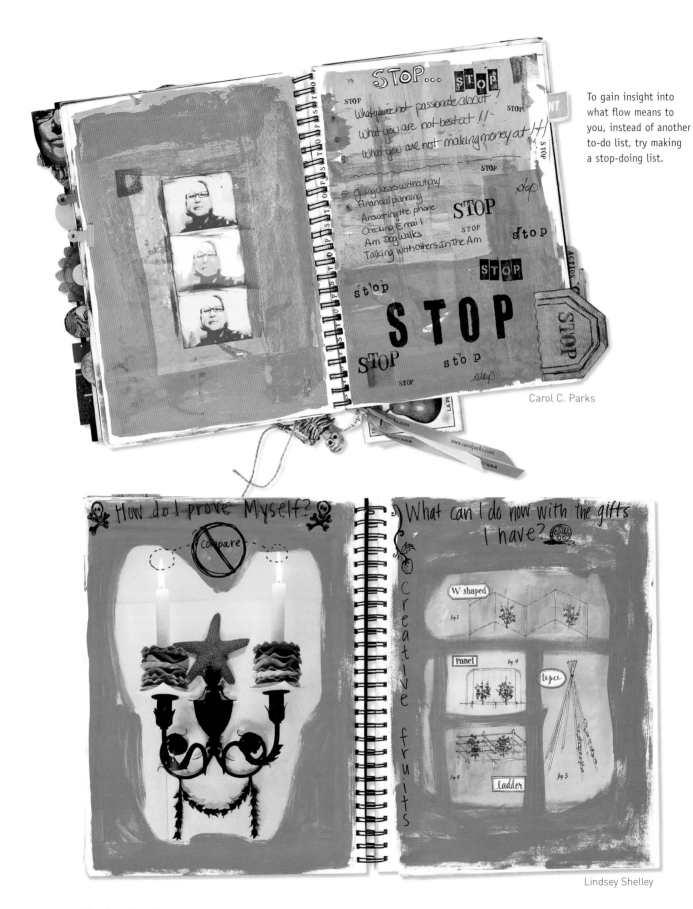

To gain insight into what flow means to you, instead of another to-do list, try making a stop-doing list.

STOP... STOP

STOP
What you're not passionate about!
What you are not best at!!
What you are not making money at!!!

STOP

STOP

- Giving classes without pay
- Financial planning
- Answering the phone STOP
- Checking Email STOP stop
- Am Dog Walks
- Talking With Others In the Am STOP

STOP

stop STOP

STOP stop STOP stop

STOP

Carol C. Parks

How do I prove Myself?

Compare

What can I do now with the gifts I have?

Creative fruits

W-shaped
fig 2

Panel fig 4 tepee

ladder fig 5
fig 6

Lindsey Shelley

Exploring the Pathway of Gifts and Flow

- What do you do so well you barely exert effort to do it?
- What comes naturally or easily to you?
- What do people compliment you on accomplishing that seems easy to you?
- What do you get absorbed in for hours?
- What do you do that feels like rowing against the current?

- When are you most in flow? What are you doing? What is the situation?
- Your unique gifts are:
- The things you are better at than anybody else include:
- What would you like to stop doing, even if you're good at it?
- If you were using your creative capacities to the fullest, you would:
- How are you being underutilized?

GIFTS & FLOW

WHAT COMES NATURALLY OR EASILY TO YOU?

WHAT DO I DO SO WELL THAT I BARELY HAVE TO EXERT EFFORT? Designing & writing knit & crochet patterns; dyeing fibers; mixed media artwork - journal pages

WHAT DO PEOPLE COMPLIMENT YOU ON ACCOMPLISHING THAT SEEMS SO EASY TO YOU? same as above

WHAT DO YOU GET ABSORBED IN FOR HOURS? Working in my visual journal or any other art projects; making things

WHAT AM I DOING THAT FEELS LIKE ROWING AGAINST THE CURRENT? Bookkeeping; trying to make money

WHEN AM I MOST IN FLOW? WHAT AM I DOING? WHAT IS THE SITUATION? When I'm working on an art project or my journal, not worrying about the outcome

MY UNIQUE GIFTS ARE.

THE THINGS I AM BETTER AT THAN ANYBODY ELSE INCLUDE: technical editing, expressing myself in my journal & not worry about what people think

WHAT WOULD I LIKE TO STOP DOING, EVEN IF I'M GOOD AT IT? worrying about making money

IF I WERE USING MY CREATIVE CAPACITIES TO THE FULLEST I WOULD: Be making a comfortable living as an artist

HOW ARE YOU BEING UNDERUTILIZED? Not enough people know about me - I'm like the sleeper art films

Traci Bunkers

"Know what turns you on so you can have lots of it in your life."

—Sas Colby

Andrew Borloz

Design your own symbol for the Creative Entrepreneur Mandala to help you think through opportunities and how they fit with your overall plan as they arise.

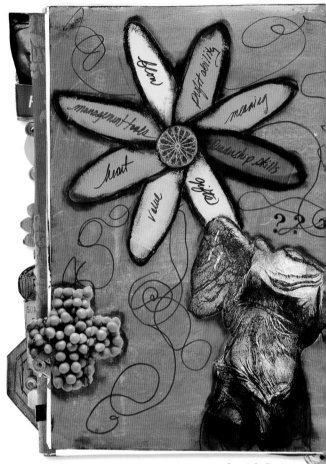

Carol C. Parks

The first two pathways focus internally on assessing the qualities that make you uniquely you and how that understanding helps you focus on the unique contribution your work can make. They are based on how you sense and feel—familiar territory for right-brain-dominant creative types. The second two pathways are externally focused on the marketplace and customers, providing a framework for analytical thinking and strategic planning and action.

Pathway 3: Value and Profitability

What is the unique value you offer your customer? Essentially, this is how you make money. Please do not confuse your value as a person, or the value of your creative work, with the concept of value as defined by the marketplace. This is a common mistake creatives make. When we create something, offer it for sale, and no one buys, we conclude that our work—or ourselves, or both—is worthless. The consequences of this line of destructive thinking are never good. It's more constructive to understand that value in the marketplace is defined by the customer's willingness to purchase the goods or services for the asking price. Think of it this way: We profit when we provide value people are willing to pay for and when we are able to communicate that value in ways our customers can understand.

Why Value and Profitability Are Important

If no value is created, neither are customers. Focusing on creating value when deciding what shape your business will take doesn't hinder or limit the creativity of the business, but actually brings about innovation that uniquely

solves problems for customers. When you do this, your customers think you are a genius! Solving problems for customers in novel ways is fundamental to the success of the business because it helps to hedge against competition and piracy.

Learning to evaluate the needs of the marketplace will help you test and refine your business ideas so that they are customer focused. Chapters 4 and 5 provide tools for evaluating the marketplace and developing customer-focused businesses.

Brainstorm what you have to offer that solves a problem for your customer or fills a void in the marketplace. Chapter 5 covers marketing promotion and shows you how to be sure your product offers value, and how to communicate that value in a way your customer understands.

Profitability is the capacity of your product or service to generate enough income to cover costs of goods sold and overhead, plus salaries of all employees (including the owner!), with money left over to either reinvest in the business or cash out as dividends. Can what you are selling generate profit? If not, then this is an area to research and course-correct as soon as possible. Pricing and financial projections are beyond the scope of this book, but good resources are available on the Creative Entrepreneur website. (See the resources section.)

Why Value and Profitability Alone Are Not Enough

For creative entrepreneurs, doing work just for the money is rarely satisfying over the long run. The nature of entrepreneurship is the desire to innovate and offer something new, possibly something not yet financially proven in the marketplace. Each possible pursuit carries an opportunity cost. Whenever we say yes to something, we are by definition saying no to something else. When considering new business ideas or directions, taking into account all four pathways of the mandala helps clarify the decision-making process and gives a certain confidence that the decision is based on a balanced array of factors.

[myth]

If only I had unlimited time, money, and the perfect space, then I could do the work I really want to do.

[reality]

Plenty of people out there have the aforementioned perfect circumstances and they are *still* not doing the work they long to be doing. Believe it or not, limitation is good for the creative process *and* good for business. What limitations are you experiencing now that you could turn around into creative opportunities?

Exploring the Pathway of Value and Profitability

- The problem my business solves for my customer is:

- The pain I eliminate for my customers is:

- What my business does better than the competition is:

- How am I helping my customers get what they want?

- What do I do to enhance the value my customers receive from my product/service?

- How do I astonish my clients?

- If they were to evangelize about my work, what would they say?

- If I were to sell my business, what would the valuation be? Is this attractive for the potential buyer?

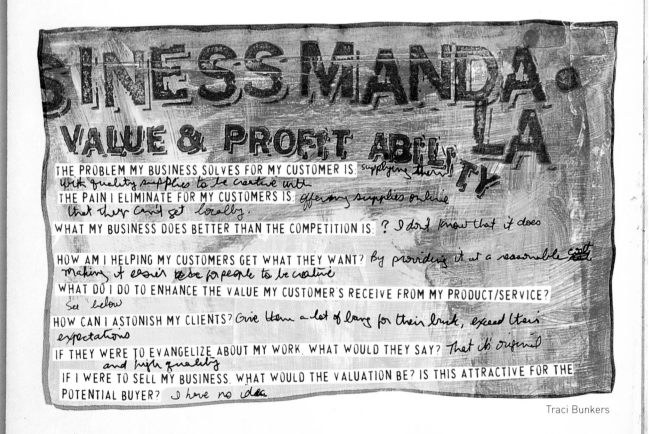

BUSINESS MANDALA

VALUE & PROFIT ABILITY

THE PROBLEM MY BUSINESS SOLVES FOR MY CUSTOMER IS: *supplying them with quality supplies to be creative with*

THE PAIN I ELIMINATE FOR MY CUSTOMERS IS: *offering supplies online that they can't get locally.*

WHAT MY BUSINESS DOES BETTER THAN THE COMPETITION IS: *? I don't know that it does*

HOW AM I HELPING MY CUSTOMERS GET WHAT THEY WANT? *By providing it at a reasonable cost, making it easier to be for people to be creative*

WHAT DO I DO TO ENHANCE THE VALUE MY CUSTOMER'S RECEIVE FROM MY PRODUCT/SERVICE? *See below*

HOW CAN I ASTONISH MY CLIENTS? *Give them a lot of bang for their buck, exceed their expectations*

IF THEY WERE TO EVANGELIZE ABOUT MY WORK, WHAT WOULD THEY SAY? *That it's original and high quality*

IF I WERE TO SELL MY BUSINESS, WHAT WOULD THE VALUATION BE? IS THIS ATTRACTIVE FOR THE POTENTIAL BUYER? *I have no idea*

Traci Bunkers

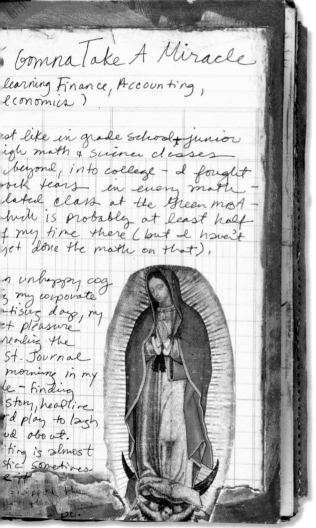

Managerial tools like quantitative analysis used to be a major stumbling block for the author.

Lisa Sonora Beam

Pathway 4: Managerial Tool and Leadership Skills

You can be smart, gifted, creative, and even provide value to your customers, but without the managerial tools and leadership skills to manage your business and yourself, you are likely to experience short-lived success. Managerial tools encompass the financial, marketing, and business development models and strategies necessary for business operations.

The Creative Entrepreneur Mandala is a business development tool. So are the SWOT analysis and SMART objectives model, which are described later in this book. These tools require some practice and experience to use, but they can be learned and applied by anyone. Leadership skills include areas of personal and professional development such as excellent communication and presentation skills, salesmanship, savvy in working well with suppliers, employees, and customers, and a commitment to continuous improvement in these areas. These are skills that must be learned and practiced; they rarely come naturally to most people. In fact, making presentations is rated as more terrifying than death itself on a scale of most-feared scenarios.

"Don't get good at what you don't want to be doing."

—Anonymous

I am a firm believer that people who apply the four pathways of the Creative Entrepreneur Mandala experience little competition simply because most people do not make the effort to develop in each area. The outcomes achieved by those who do are significant. Financially, it could mean the difference between living month to month and achieving financial independence. Creatively, it could mean slogging away at work you feel lukewarm about or engaging in work that challenges you and therefore brings out the best you have to offer. What is it worth to you to learn some managerial tools and apply them rigorously? What will it cost you if you don't?

Brainstorming leads to the insight that the Tools and Skills quadrant is the most important way to make a difference in business at this time.

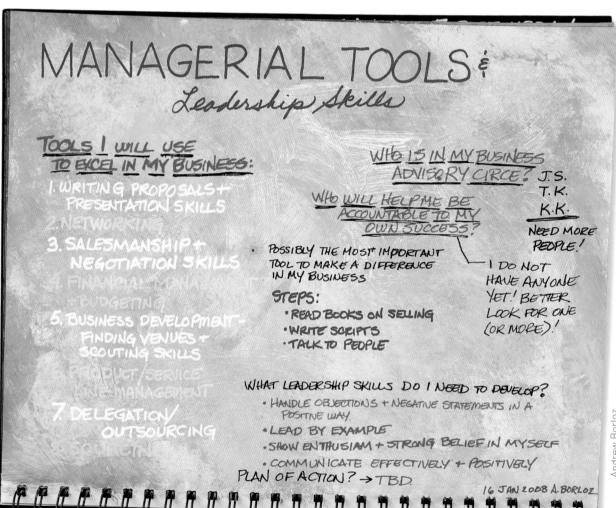

MANAGERIAL TOOLS &
Leadership Skills

TOOLS I WILL USE
TO EXCEL IN MY BUSINESS:

1. WRITING PROPOSALS + PRESENTATION SKILLS
2. NETWORKING
3. SALESMANSHIP + NEGOTIATION SKILLS
4. FINANCIAL MANAGEMENT + BUDGETING
5. BUSINESS DEVELOPMENT - FINDING VENUES + SCOUTING SKILLS
6. PRODUCT / SERVICE MANAGEMENT
7. DELEGATION / OUTSOURCING

WHO IS IN MY BUSINESS ADVISORY CIRCLE? J.S.
T.K.
K.K.

WHO WILL HELP ME BE ACCOUNTABLE TO MY OWN SUCCESS?

NEED MORE PEOPLE!

• POSSIBLY THE MOST* IMPORTANT TOOL TO MAKE A DIFFERENCE IN MY BUSINESS

I DO NOT HAVE ANYONE YET! BETTER LOOK FOR ONE (OR MORE)!

STEPS:
• READ BOOKS ON SELLING
• WRITE SCRIPTS
• TALK TO PEOPLE

WHAT LEADERSHIP SKILLS DO I NEED TO DEVELOP?
• HANDLE OBJECTIONS + NEGATIVE STATEMENTS IN A POSITIVE WAY.
• LEAD BY EXAMPLE
• SHOW ENTHUSIASM + STRONG BELIEF IN MYSELF
• COMMUNICATE EFFECTIVELY + POSITIVELY
PLAN OF ACTION? → TBD.

16 JAN 2008 A. BORLOZ

Andrew Borloz

Exploring the Pathway of Managerial Tools and Leadership Skills

- These are the tools I will use to excel in my business:

- What one tool, used well, would make the most significant difference in my business?

- What are the steps I will take now to begin to master this tool in my business?

- Who is in my business advisory circle?

- Who will help me be accountable for my own success?

- What leadership skills do I need to develop?

- What is my plan of action for developing my leadership skills?

TOOLS & SKILLS

WHAT ONE TOOL, USED WELL, WOULD MAKE THE MOST SIGNIFICANT DIFFERENCE IN MY BUSINESS?
I don't know, but I need something!

WHAT ARE THE STEPS I WILL TAKE NOW TO BEGIN TO MASTER THIS TOOL IN MY BUSINESS?

WHO IS IN MY BUSINESS ADVISORY CIRCLE? Nottoll- Artist's business journal workshop, Carol Parks, Sondra Beam, Jim Bateman, Juliann Coles

WHO WILL HELP ME BE ACCOUNTABLE TO MY OWN SUCCESS? Same as above

WHAT LEADERSHIP SKILLS DO I NEED TO DEVELOP? I need to learn to delegate and give grunt work to people

WHAT IS MY PLAN OF ACTION FOR DEVELOPING MY LEADERSHIP SKILLS? Write a plan, steps of what needs to be done to help me trust that someone will do it correctly

LIST THE TOOLS YOU WILL USE TO EXCEL IN YOUR BUSINESS.
the internet, my scintillating personality. Honestly, I don't know

Wow, my business side is really lacking

Traci Bunkers

Mapping Your Creative Entrepreneur Mandala

1. Respond to the journaling prompts (at right) for each pathway. This will clarify the content of your mandala.

2. Gather images and words that express the attributes you want to manifest in each of the four pathways. Try to work quickly when gathering images so the conscious/judging mind doesn't censor your choices.

3. Create a large page spread in your journal by taping extra pages to all of the page edges or use one large blank piece of paper, about 20" by 22," which can be folded and stored in your journal.

4. Draw four large overlapping ovals on the page to create an eight-petalled mandala.

5. Using the mandala diagram (page 19) as a guide, pencil in the titles of each petal.

6. Trim and paste in the images gathered for each section in the appropriate petal. Embellish with paint, markers, wax crayons, and ephemera, as desired.

7. Decorate the center area, where the petals overlap, as a separate component. One idea is to portray what the intersection of the four pathways looks like in terms of ideal work.

8. Embellish the areas outside the mandala flower with more images, words, or ephemera, and take notes on what you know now about your own unique Creative Entrepreneur Mandala.

9. Sit with the finished mandala. View it from a distance. Take some time to journal about your experience using the journalling prompts or questions of your own.

JOURNALING PROMPTS

- What are the main takeaways from creating your mandala?

- Were there surprises? Did you have any aha! insights?

- Which of the four pathways of the Creative Entrepreneur Mandala are your strongest? Your weakest?

- What can you do to capitalize on your strengths?

- What can you do to strengthen your weak areas?

- What specifically will you do, and when?

- What will you do to build in accountability and commitment?

Take Heart: What Your Mandala Reveals

It's no surprise that creative types doing the mandala exercise mostly reveal gaps in the Value and Profitability and Skills and Tools pathways. This is to be expected, as they are concerned with honing their gifts and are usually making decisions based on what has Heart and Meaning, sometimes above all else. But guess what? The *exact opposite* is true for the business managers I work with. They excel at value propositions and managerial skills and tools, and they struggle with meaning and bringing their true gifts to bear in their work. This also is not surprising. But the process can evoke shockwaves when you do it for yourself and see the gaps in your thinking, action, or feelings. There's a difference between intellectually understanding a truth and knowing it from your own experience. That's why the next exercise and entire next chapter are devoted to exploring those gaps.

Finding Business and Role Models

Who's done what you want to do? Madonna is a rock star, and she also rocks at the business side of her art. Oprah is a gifted communicator with visionary business savvy. Martha Stewart built a business empire out of artistic homemaking. All of these creative entrepreneurs not only followed paths of Heart and Meaning that used their gifts but also created tremendous value in the marketplace and developed a formidable Tool and Skill set along the way.

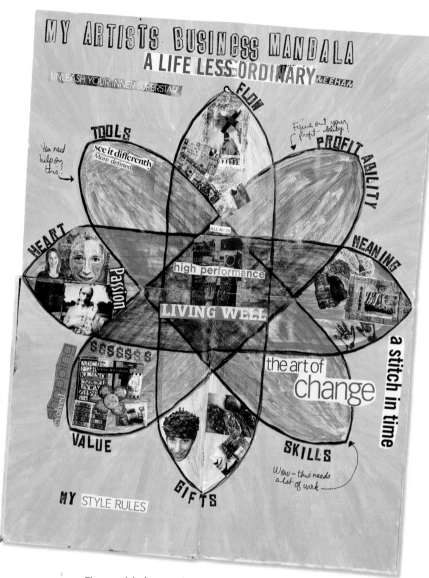

The mandala is a great tool for seeing areas that call for further exploration and development.

Traci Bunkers

Maybe you don't like them for whatever reason or don't especially aspire to be a billionaire. The point is: How can you be as good at making your business an art form in itself? Who are your creative entrepreneur role models for the work you want to do?

Meeting Your Guides

Role models and mentors don't necessarily have to be people you know. Working with guides is a powerful way to tap into the qualities and strategies others have used successfully and that you'd like to emulate.

1. Identify your guide. You might have more than one. To start, pick one person, from history or current culture, who personifies something you want to accomplish or develop.

2. Do a little research about his or her life. Find photos and other artifacts you can use to add a visual element to the relevant page in your journal.

3. Write a letter of introduction to your guide. Tell her about your hopes, dreams, fears, and why you think she can be a great mentor for you. Ask her for advice. You can write the letter right in your journal, or you can write it on a separate page or card and put it in an envelope in your journal. Paint and embellish the letter as you wish. Include a photo, an example of your work, or anything you think might help get your guide's attention.

4. Either now or sometime later, write a letter from your guide back to you. This takes some imagination, but creative entrepreneurs have plenty of that. Get in the mood and mindset of your guide and write back.

5. Continue this correspondence for as long as it serves you. You might correspond with several guides—one who is mistress of her craft, another you admire for her public relations skills, a third who is living the lifestyle you desire.

Georgia O'Keeffe is a powerful guide for many visual artists.

Leav Bolender

6. Make a list of possible real-life mentors in your business. Do you know a colleague, coach, or therapist (depending on your needs) who can offer mentorship or support? Also consider to whom you can be a mentor and support. Teaching what you know and sharing lessons you have learned is a great way of gaining clarity and strengthening your own sense of purpose.

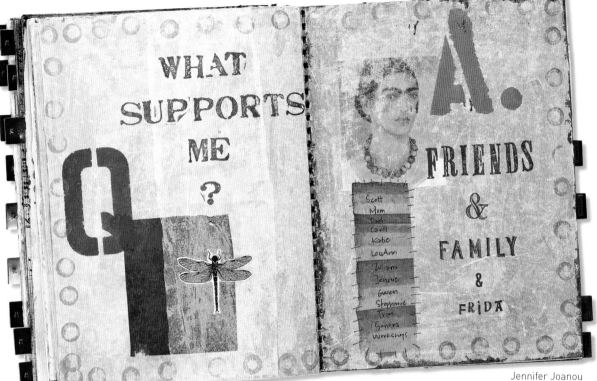

Jennifer Joanou

TOP

Who can you call on for support in your work? Mentors can be found in people you don't know personally and in those who have gone before us.

BOTTOM

The artist's spiritual connection to her creativity is nurtured by letters to and from spiritual guides.

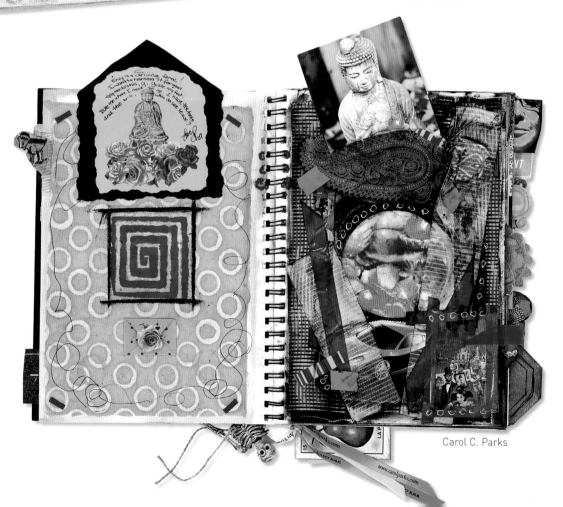

Carol C. Parks

"ART IS MEDICINE"

sonora

Soul Proprietor:
Building with Creative Blocks

Jennifer Joanou

3

AMONG THE MAIN DETERRENTS TO BRINGING new ideas into form are the emotional and psychological blocks of the creator. These blocks aren't a sign of weakness; they signal opportunities for our growth. Without the proper orientation to creative blocks, creating can feel like going off the deep end. That's why so few people dare to pursue their ideas very far—and why creatives can be branded as dysfunctional or temperamental. Maybe they are at times. But difficult behavior is usually a symptom of fear.

The hero's journey, the basis of all dramatic storytelling, encapsulates the struggle of brave souls who encounter life-threatening trials as they come closer to what they want most. A common motif in ancient cultures is the fierce deity standing at the entrance of the most sacred places, symbolizing the perilous journey toward what is most desired. So relax. You're not going crazy. Since prehistory, others have been having the same experience.

As a creative person who has encountered (and still wrestles with) creative blocks, and as a creativity teacher who has supported thousands of others in the unblocking process, I've learned some ways to understand and meet this inevitable encounter with the guardian demons standing between you and where you want to go.

Creativity is a soul's journey. It requires courage and some good tools for either charming the fierce deities or kicking their butts. Are you ready?

Left Brain/Right Brain: Why Not Use the Whole Thing?

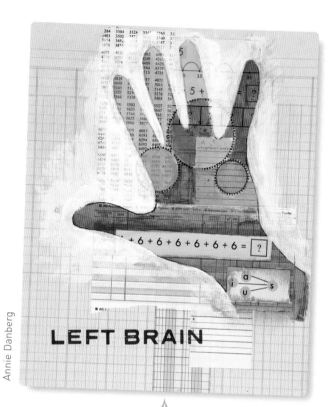

Annie Danberg

LEFT BRAIN

The terms *left-brained* and *right-brained* come from research that shows which side of the brain processes information and how we operate in various modes of thinking. The thought processes and behaviors of left-brained people are based on logic, reason, analytical thinking, and verbal communications. Right-brained people are the classic artistic types, whose thinking and behavior are based on emotion, intuition, visual thinking, and nonverbal types of communication. Just as we have a dominant hand, we have a dominant side of the brain that becomes preferential. As we rely on the capacities that come naturally to us, we tend to avoid using the nondominant capacities.

Because business strategy tools are made up of linear, logical, left-brain activities, it's necessary to develop these capacities—which can mean moving out of one's comfort zone.

Most education is designed for and by left-brained thinkers. Right-brain modes are not only passed over but also often actively discouraged (Were you ever reprimanded for daydreaming, not following the directions, or not sitting still?). In learning environments that are foreign to our way of processing information, we can feel confused at best, stupid at worst. Frustration fuels fear that we'll never get it, making it even harder to learn. It's a vicious cycle.

LEFT-BRAIN CHARACTERISTICS

- Manifests conscious awareness
- Likes concrete analysis
- Deals with parts and specifics
- Displays critical thinking based on logic
- Has an external focus
- Relies on linear, sequential, step-by-step thought patterns
- Accomplishes one task at a time
- Has clear priorities and written lists
- Focuses on details and facts
- Focuses on what is actually said (facts)
- Understands verbal instructions, both oral and written
- Makes decisions based on facts
- Focuses on mastering mechanics
- Reads instruction manuals
- Plans
- Implements order, control
- Is time bound
- Is future oriented
- Thinks convergently, systematically brings ideas together, generates conclusions and clear next steps

Because right-brain learners are visually oriented, it's challenging for them to learn through oral or written instruction only. They need pictures and graphics to help them understand, and they learn best by putting ideas into action through creative experimentation.

Understanding left-brain/right-brain modes of thinking is one reason why working with the tools in your journal is so powerful, whatever your preferred learning style. Left-brain concepts are presented in ways the right brain likes to learn. For left-brained types, having to think and respond spontaneously and visually is a challenge; doing so gives the right brain a good workout, contributing new ideas and insights. Think of it as creative cross-training. The overall result is a more integrated individual, able to pull from a variety of tools and mindsets appropriate to the task at hand.

Understanding how your own thought process works helps you develop in ways not just critical to your business but relevant to the quality of your whole life. When you use capacities previously foreign to your experience, you'll learn how to

- Become conscious of how you best learn, think, and solve problems.

- Identify your own strengths and weaknesses.

- Know whether the thought process you are using is appropriate to the task you are working on.

- Grow mentally and emotionally as you develop your nondominant side.

RIGHT BRAIN

RIGHT-BRAIN CHARACTERISTICS

- Manifests unconscious awareness
- Follows gut feelings and intuition
- Deals with wholes, how parts work together
- Uses fantasy and imagination
- Has internal focus
- Uses random, circular, simultaneous thought patterns
- Skips around, is a multitasker
- Keeps an ongoing mental list of to-do items
- Imagines the big picture
- Focuses on how something is said (feelings)

- Learns by doing or by seeing a picture
- Makes decisions based on feelings
- Is fluid
- Is chaotic, unstructured
- Is timeless
- Is oriented to the now
- Dives in, figures out by doing
- Thinks divergently, uses mind mapping, brainstorming, associative activities that generate even more ideas
- Impatient with how, needs to know why

How Doing Math Made Me a More Happy, Productive Artist

People who knew me as a typical right-brained artistic type who shied away from numbers and linear thinking were shocked when they found out I was in business school. I joked that in order to do the work, I had to grow another brain. Little did I know that this was exactly what was happening, until I had the biggest breakthrough in my artistic and business life simultaneously.

About a year into my MBA, I was working on a design project for a client. After working peacefully for a couple hours on a new concept, I suddenly realized that all the usual stress and anxiety of facing the blank page and having to create on demand was absent. I wasn't questioning my value as a designer or stressing about what the client would think of the work (or me) or how it (or I myself) might not be good enough. I was simply, miraculously, working away without negative comment from my inner critic and without feeling overwhelmed. This was so contrary to my usual experience that it startled me.

Trying to figure out what had happened, I remembered something from my psychotherapy training in Carl Jung's work. He said that when you strengthen your nondominant capacities, what you are naturally good at gets stronger. For me, this meant all the math, quantitative analysis, and linear thinking required for my coursework not only gave me new skills but was also working behind the scenes, strengthening my natural powers of creative intuition and imagination —all the things that have come easily and naturally to me. Exercising my nondominant functions not only helped me do the math—literally—but opened up new worlds of anxiety-free creativity.

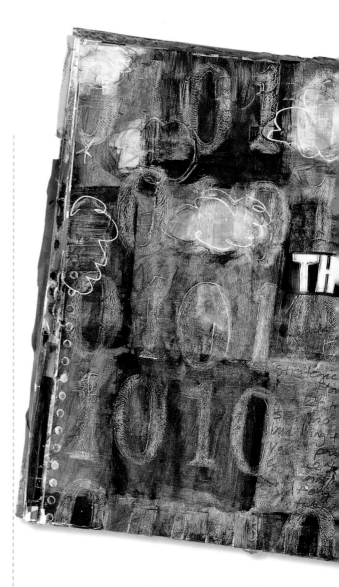

The artist depicts her left brain as a chessboard of binary code, symbols of strategic thinking and logic, with some dreamy ideas, represented by clouds, drifting in. The halo and coronation angels are a playful reminder of her epiphany about right-brain/left-brain integration that allows her to easily travel back and forth to the productive creative state she calls Imagine Nation.

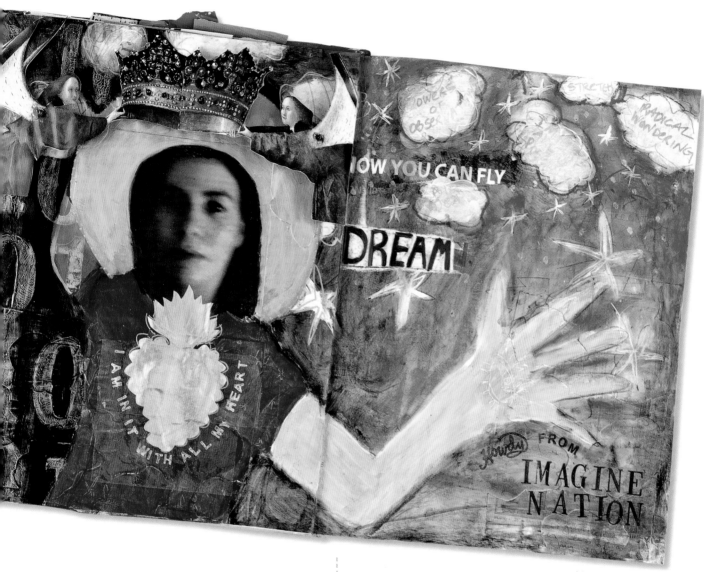

Lisa Sonora Beam

<table>
<tr><td>[myth]</td><td>[reality]</td></tr>
<tr><td>If I learn how to master the business side of art, I will lose my creative edge.</td><td>Whenever we strengthen our nondominant abilities (for right-brained types, this means getting good at quantitative, linear, logical functions), what we are naturally good at gets even stronger.</td></tr>
</table>

Befriending My Left Brain

I used to live primarily guided by the right brain and was suspicious and rejecting of all left-brained activities—math, making order, keeping a schedule. I sucked at those things. Then I went to college (at the ripe age of forty-four!) and had to tackle, or rather master, those left-brain skills in order to succeed.

Making this journal page helped me see my current relationship to the left and right sides of my being. I find I value the left more than ever; it's the side that gets things done. But I'm seeing that both sides are crucial. Like a good relationship, these two sides support each other and offer strengths the other lacks. The right side loves to dream things up and can see the big picture. The left side knows the steps and can make an action plan to make dreams realities.

My big aha! moment: I spent two hours doing schoolwork (left-brain heavy lifting), and then I took a one-hour break to work in my visual journal. Not only did this refresh me, I got insights for solving a school problem that was vexing me. I got a ton done that day and was happy doing it.

—Annie Danberg

A spiral-bound lab book creates the backdrop for paint, gesso, glued bits of accounting sheets, and notes torn from the artist's written journal, accentuated with vintage alphabet rubber stamps.

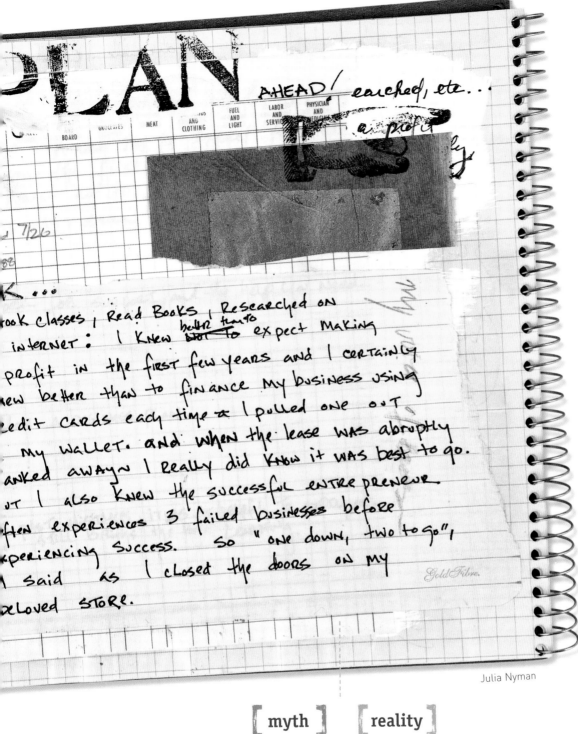

PLAN AHEAD! earched, etc...

BOARD	GROCERIES	MEAT	AND CLOTHING	FUEL AND LIGHT	LABOR AND SERVICE	PHYSICIAN AND MEDICINE	

7/26

K...

rook classes, Read Books, Researched on
internet: I knew ~~not~~ better than to expect making
profit in the first few years and I certainly
new better than to finance my business using
edit cards each time I pulled one out
my wallet. and when the lease was abruptly
anked away I really did know it was best to go.
ut I also knew the successful entrepreneur
ften experiences 3 failed businesses before
xperiencing success. So "one down, two to go",
I said as I closed the doors on my
beloved store.

Gold Fibre

Julia Nyman

[myth] [reality]

Because I'm right-brained, I just don't have what it takes to succeed in business.

Brain hemisphere dominance is largely a matter of habit. We rely on the cognitive functions that come easiest to us. But just like building muscle, you can exercise the other side of your brain and develop skills that previously seemed impossible.

JOURNALING PROMPTS

- What capacities feel the easiest?
 What do you tell yourself about them?

- What capacities cause the most frustration?
 What do you tell yourself about them?

- Which capacities have the most positive
 impact on your creative work life?

- Which capacities have the most negative
 impact on your creative work life?

- What character attributes or stereotypes
 do you associate with the various capacities?

- My left brain wants/doesn't want to:

- My right brain wants/doesn't want to:

- Try writing a dialogue between the two sides.
 What do they say to each other?

- Make an image that portrays both sides of
 the brain, right and left. Which side is more
 dominant for you? How do you experience
 your left-brain/right-brain capacities?

IMAGING TIP

You don't have to literally draw a brain.
What other images can you use to portray
the left-brain/right-brain concept? Are the
parts equal, or do you want to make your
dominant side larger? Try using a central
image to characterize each side and then
collage over that initial layer.

VISUAL JOURNAL EXERCISE

Creating Your Left-Brain/Right-Brain Map

1. Start with a new two-page spread in your journal.

2. Begin by writing quick responses to the following
 writing prompts in your journal. You can write
 directly on the spread and then collage over it or
 use a separate blank page in your book.

3. Use the writing prompts to the left to help you focus
 on how you experience left-brain/right-brain
 capacities.

Loves:
unstructured time
watching nature
dreaming
listening to music
making art

GRASP

Tracings of the artist's hands
are placed on opposite sides
of the dominant brain hemi-
sphere, portraying how the
left brain rules the right side
and vice versa.

"When the 'weaker' of the two brains (right and left) is stimulated and encouraged to work in cooperation with the stronger side, the end result is a great increase in overall ability and...often five to ten times more effectiveness."

—Robert Ornstein

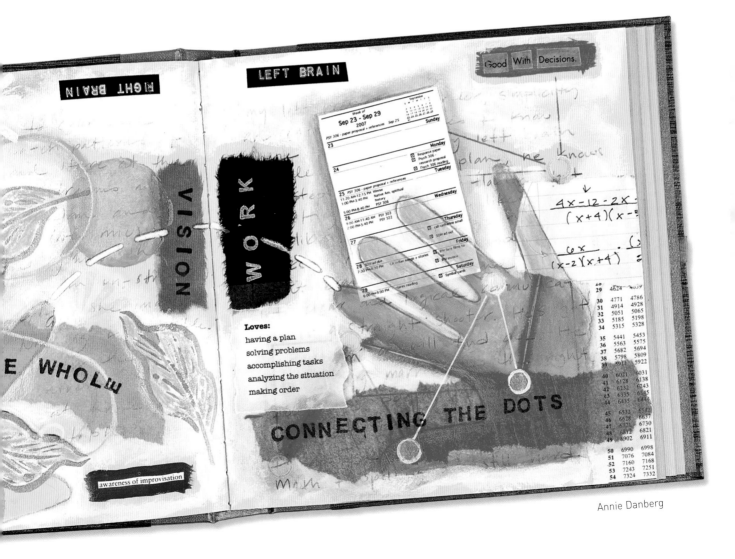

Annie Danberg

Sensing, Thinking, Feeling, Acting: Mastering the Four Modes of Functioning

The four modes of functioning is a powerful model for analyzing what gets in the way of achieving success and what can support us in fruitful engagement in both life and work. Without awareness of the modes of functioning, how we get things done (or not), and how we work and think and feel can seem accidental, out of our control, or beyond our ability to change or manage.

When we strengthen our nondominant capacities, we gain new skills and new resources, not only in the areas we are working on but in our dominant capacities as well. This is how getting good at business can help you function even more effectively in your creative endeavors.

What Are the Modes of Functioning?

The four modes of functioning are sensing, thinking, feeling, and acting. These modalities and how we use them influence our moods, thought process, energy, and outcomes—ultimately affecting our results. Each of the four functions has both constructive and destructive characteristics. If you are not producing the results you want, it could be because

1. One of the functions is dominating all the others.
2. The appropriate function is not being used for the right situation or is being used at the wrong time.
3. The constructive aspects of a function(s) are not known and harnessed.
4. The destructive aspects of a function(s) are causing severe distress to the entire system.

In this section, you'll learn how sensing, thinking, feeling, and acting operate constructively and destructively, and how to harness them to help you accomplish what you want.

Just as we naturally develop a dominant side of the brain, we also gravitate toward mental, emotional, and physical habits that become familiar and feel most at home to us. Mapping the unique ways the modes of functioning operate in your life (see visual journal exercises beginning on page 58) is a nonjudgmental way to explore whether or not these habits are in service to what you really want to be and create.

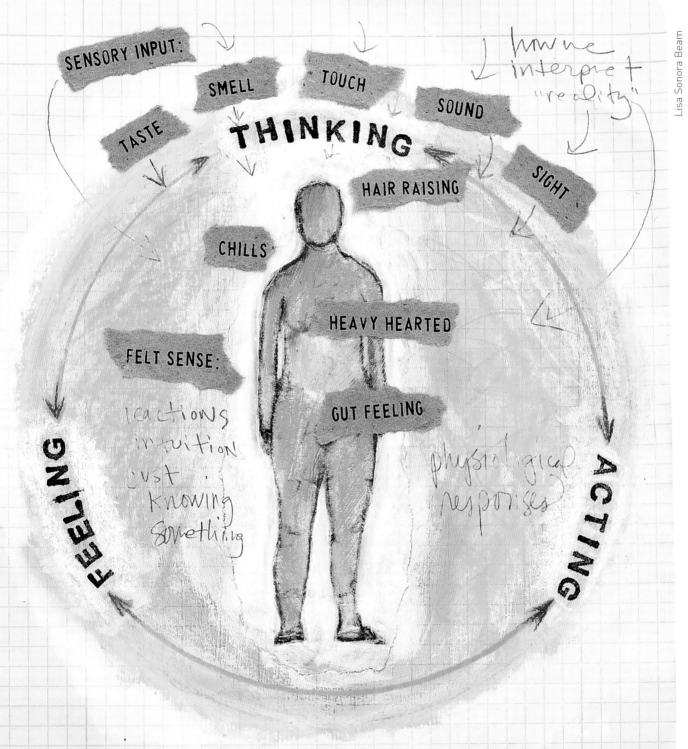

SENSORY INPUT:

SMELL

TOUCH

SOUND

TASTE

THINKING

how we interpret "reality"

HAIR RAISING

SIGHT

CHILLS

HEAVY HEARTED

FELT SENSE:

GUT FEELING

reactions
intuition
just
knowing
something

physiological responses

FEELING

ACTING

THE MODES OF FUNCTIONING

We take in data through our senses, and that creates thoughts and feelings. The thoughts we think create feelings. The feelings we feel influence our thoughts. How we think and feel leads to behaviors, ways of responding, that can be seen as actions. These actions lead to the results we get. To get different results, we can use this model to go back to the source of our actions.

Sensing Function

The sensing function is associated with the five senses, felt sense, and intuition. Sensing is experienced externally through the senses of sight, sound, touch, hearing, taste. Sensing is also experienced internally, as the felt sense of physical sensations, such as when the hair stands up on the back of your neck, or your palms get sweaty, or you have butterflies in your stomach. Intuition and gut reactions are also manifestations of the sensing function.

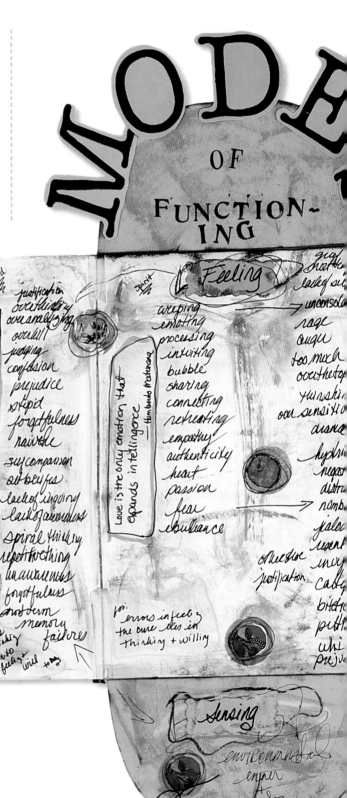

A three-page journal
entry with fold-out panels
illustrates the four modes
of functioning with space
for more notes and mus-
ings about how these are
experienced by the artist.

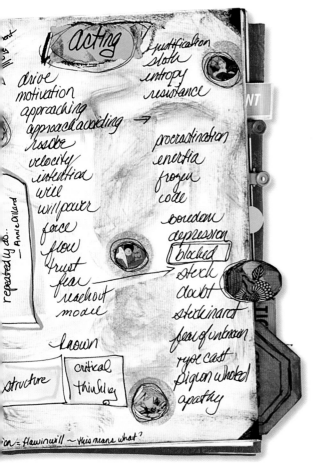

Carol C. Parks

CONSTRUCTIVE SENSING

- Being able to turn one's attention inward and know how one is experiencing something on a sensory level

- Perceiving emotions or attitudes that are not spoken

- Gathering information expressed in gestures or body language

- Clarity of knowing and decision making that is not clouded by preconceptions, predispositions, or the influence of past experiences

- Intuitive understanding

- Clarity of perception

DESTRUCTIVE SENSING

- Not being able to translate perceptions into information that is useful or leads to an advancement of one's work

- Being highly sensitive to sensory input in a way that interferes with one's ability to function

- Relying only on sensing or intuition for all decision making

- Not engaging in constructive thinking

- Generalizing information based on past experiences in a way that may not be relevant

- Gut reactions or intuitions that are really projections of one's own fears

Thinking Function

The thinking function is associated with the mind. It's how we use our thought process and cognitive and intellectual capabilities.

CONSTRUCTIVE THINKING

- Learning new skills and tools for problem solving
- Asking good questions
- Making decisions
- Performing quantitative analysis (doing the math)
- Planning for scenarios in advance
- Performing research
- Thinking critically
- Solving problems
- Budgeting
- Creating schedules
- Being aware of stressful thoughts and being willing to question them
- Actively imagining
- Developing awareness of thoughts as they arise
- Cultivating open mindedness
- Focusing on what you want to create
- Working with mental models (like those presented here)

DESTRUCTIVE THINKING

- Comparing, judging, and being jealous in ways that result in envy, resentment, and bitterness
- Believing what you think is true
- Being unaware of stressful thoughts
- Believing there is a price to pay for living your purpose/passion (that you cannot afford to pay)
- Mismatching; finding fault with any potential solution (saying "yes, but...")
- Reinventing the wheel
- Arguing for your limitations
- Not questioning limiting beliefs
- Lacking insight
- Lacking the tools to question mindset
- Maintaining a know-it-all mindset
- Cultivating closed-mindedness
- Blaming circumstances and others for your situation
- Persisting in negative self-talk
- Being pessimistic
- Worrying excessively due to obsessive negative thinking
- Not considering the opinions and viewpoints of others

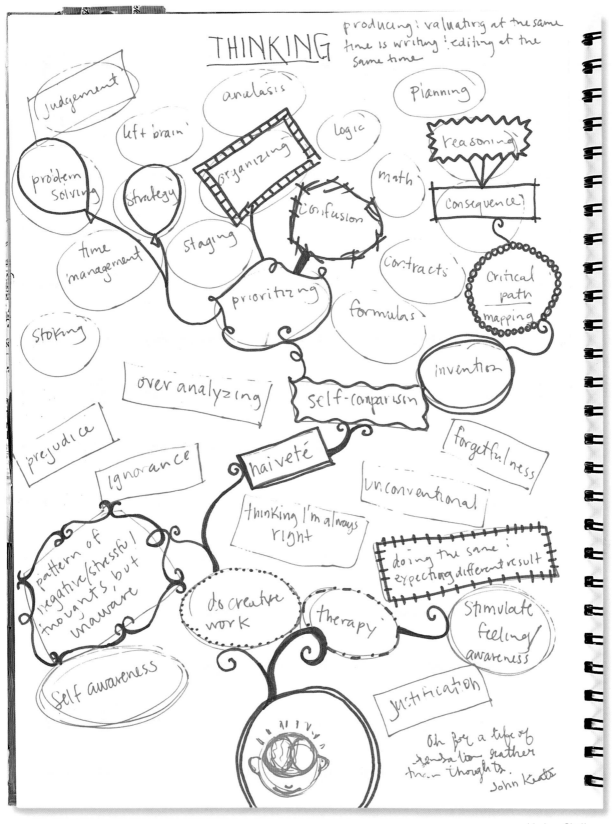

THINKING

producing + valuating at the same time is writing + editing at the same time

- Judgement
- analasis
- Planning
- left brain
- logic
- reasoning
- organizing
- math
- consequence
- problem solving
- strategy
- confusion
- critical path mapping
- time management
- staging
- contracts
- prioritizing
- formulas
- stoking
- invention
- over analyzing
- self-comparisin
- prejudice
- naiveté
- forgetfulness
- ignorance
- unconventional
- thinking I'm always right
- doing the same + expecting different result
- pattern of negative/stressful thouants, but unaware
- do creative work
- therapy
- stimulate feeling awareness
- self awareness
- justification

Oh for a life of sensation rather than thoughts. John Keats

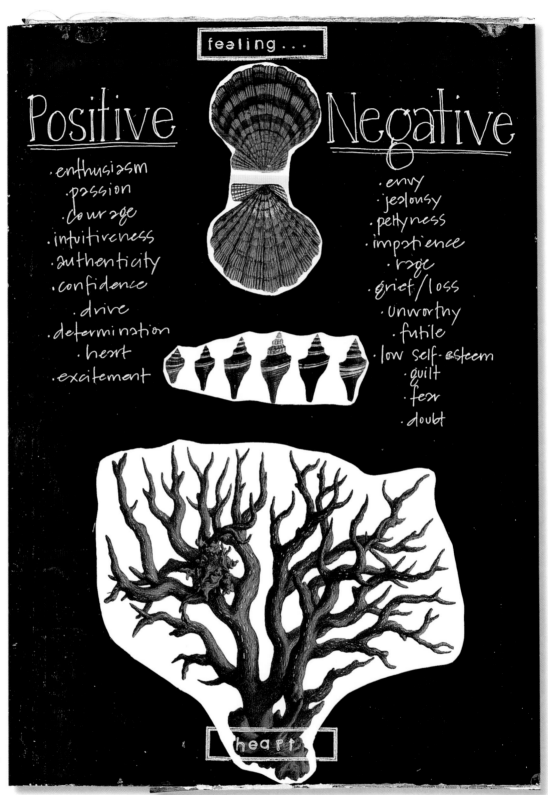

feeling...

Positive
- enthusiasm
- passion
- courage
- intuitiveness
- authenticity
- confidence
- drive
- determination
- heart
- excitement

Negative
- envy
- jealousy
- pettyness
- impatience
- rage
- grief/loss
- unworthy
- futile
- low self-esteem
- guilt
- fear
- doubt

heart

Constructive and destructive aspects of feeling are visualized and connected with attributes of the heart.

Jennifer Joanou

Feeling Function

The feeling function is associated with the heart. It has to do with emotional responses and how we experience emotions.

CONSTRUCTIVE FEELING

- Awareness of feelings
- Using feelings to gain information, to solve problems, to create
- Cultivating self-compassion, kindness, patience with one's own state of being and growth process
- Enjoying the process
- Inspiring imagination
- Cultivating positive emotions such as joy, contentment, delight, curiosity, happiness
- Learning new habits of feeling that make you feel better, not worse
- Expressing appreciation
- Practicing gratitude, consciously knowing what you are grateful for
- Developing awareness of stressful thoughts underneath negative feeling states
- Expressing true feelings without emotional drama
- Being at peace; cultivating states of focus, calm, clarity
- Questioning relationship of feelings to the work of achieving your goal

DESTRUCTIVE FEELING

- Allowing feelings such as fear, doubt, anger, sadness to run unchecked
- Being highly reactive, easily triggered (quick to anger, rage)
- Creating drama, blowing things out of proportion
- Experiencing anxiety and overwhelming depression without dealing with them or treating them
- Assuming good things that occur are accidental
- Fearing when the other shoe will drop
- Lacking self-trust, self-confidence, self-esteem
- Not trusting your own experience
- Blaming others for how you feel
- Wallowing in negativity, feeling the glass is always half empty
- Maintaining pessimism, doubt, and skepticism that block working or the creative process

Acting Function

The acting function is associated with physical doing, the body, and movement. It encompasses the actions we take—or do not take—in response to a thought or feeling.

CONSTRUCTIVE ACTION

- Doing your creative business projects

- Doing your creative work

- Pursuing creative processes that keep your creative well full

- Taking things step by step

- Tracking regular, incremental progress, step-by-step action plans

- Setting and keeping timelines

- Scheduling in nurturing activities regularly

- Setting up your work environment to promote concentration, efficiency

- Meditating, connecting with your spiritual source of nourishment

- Exercising, enjoying movement of any kind

- Eating nutritious food for good energy and clarity of mind

- Learning what works for your body and doing it

- Taking breaks

- Balancing activity with rest

- Staying hydrated

- Developing a support system of friends and people who champion you and your work

- Engaging in regular creative practices such as visual journaling, morning pages

DESTRUCTIVE ACTION

- Not knowing where to begin or how to keep going

- Not seeking information or instruction on work process

- Waiting until you feel inspired or "feel like it" to begin working

- Blowing off deadlines, not keeping agreements

- Admitting distractions: internet, phone, television, reading, shopping

- Eating emotionally

- Giving up when things are hard

- Abandoning projects before completing them

- Overextending, not setting boundaries

- Overpromising, underdelivering

- Staying "too busy"

- Not recognizing your limits

- Indulging in mood-altering activities: drugs, drink, sex, or whatever you do that makes you feel better for a moment and then makes you feel worse

- Maintaining a chaotic, disorganized space

- Isolating self, not reaching out for good companionship

- Doing things the same way and expecting a different result

- Raising the bar too high, expecting to go from A to Z in two steps rather than twenty-six

- Working in fits and starts

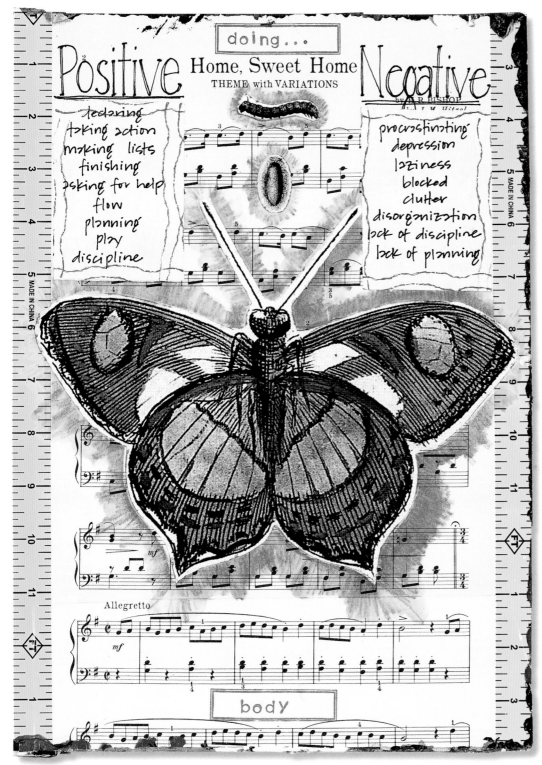

Constructive and destructive aspects of acting are visualized and connected with attributes of the body.

Jennifer Joanou

How the thinking function is experienced, creatively and destructively, with remedies for destructive thinking.

HAVE YOU EATEN?
PROTEIN/VEGGIES/GREEN DRINK

HYDRATED?

SLEPT?

BEEN OUTSIDE?
GO TAKE A HIKE
RIDE YOUR MOUNTAIN BIKE

DONE CREATIVE WORK
FIRST THING?

FILLED THE WELL?
MEDITATION
YOGA
ECSTATIC DANCING
JOURNALLING
PHOTOGRAPHY
BUBBLE BATH

HAD FUN LATELY?

DO ABSOLUTELY NOTHING

OR

DO SOMETHING

...IT ALL DEPENDS...

Our society is particularly focused on the thinking and acting functions. We are taught that lessons are learned and problems are solved by getting the right answers, using your head, rolling up your sleeves, and persevering. This approach can get us a certain distance in many situations but makes limited use of our full abilities. How to think critically and how to engage in effective action are not routinely taught, and even if they are, the other half of our capacities, our sensing and feeling functions, are ignored or misunderstood. If a person happens to be particularly feeling or sense-oriented (as creatives often are),

he or she often finds it difficult to achieve consistency of results through thinking and action alone.

Creatives are blessed (and sometimes feel cursed!) with an abundance of feeling and sensing capabilities. This is a kind of mysterious cauldron where original ideas form. The challenge here is to stay tuned to the intuitive, feeling, sensory abilities while also learning to engage the thinking and doing capacities in ways that have heart and meaning. Of course, for everyone, the ultimate goal is to enhance the constructive aspects of all the modes of functioning while minimizing their destructive aspects.

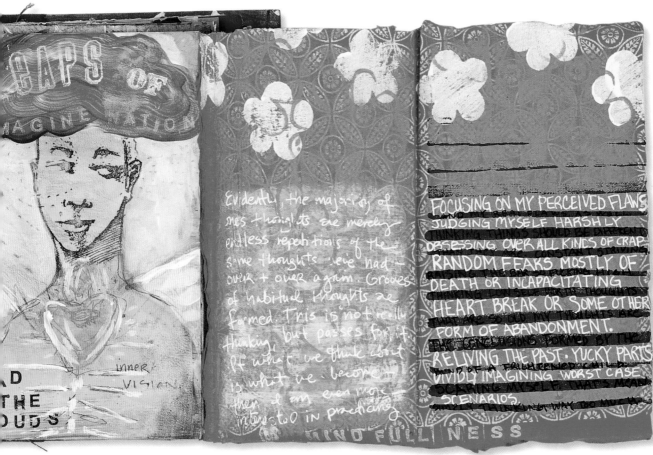

Evidently, the majority of ones thoughts are merely endless repetitions of the same thoughts we've had over + over again. Grooves of habitual thoughts are formed. This is not really thinking, but passes for it. If what we think about is what we become then I am even more interested in practicing

inner VISION.

MIND FULLINESS

FOCUSING ON MY PERCEIVED FLAWS AND JUDGING MYSELF HARSHLY THINKING THINGS SHOULD BE DIFFERENT OBSESSING OVER ALL KINDS OF CRAP THAT I HAVE NO CONSTANT DRIVING RANDOM FEARS MOSTLY OF TELLING MYSELF NEGATIVE THOUGHTS DEATH OR INCAPACITATING THAT ARE SO OLD MY THOUGHTS ARE HEART BREAK OR SOME OTHER THE GROOVES DUGS FORMED BY THE FORM OF ABANDONMENT. MIND OF A FRIGHTENED CHILD RELIVING THE PAST. YUCKY PARTS AND I OFTEN FEEL ITS VIVIDLY IMAGINING WORST CASE SCARING MYSELF THAT'S MEAN SCENARIOS. AND STUPID WHY DO I DO IT

Lisa Sonora Beam

Remedies for Destructive Aspects

The most useful thing about understanding how the modes of functioning work is that they reveal trouble spots and associated remedies. *The remedy for any destructive aspect of a function is always found in one of the constructive creativity areas of the other functions.*

- Destructive thinking is remedied through constructive feeling and action.
- Destructive feeling is remedied through constructive thinking and action.
- Destructive action is remedied through constructive thinking and feeling.

Constructive sensing can be developed as an act of self-inquiry (looking within for answers and insight), and by engaging in constructive activities of the other modalities. This is an ongoing practice, similar to meditation, that positively affects the other modes of functioning.

The following exercises show you how to map your own experience with the thinking, feeling, acting, and sensing functions to understand how their constructive and destructive aspects operate in your life and work. This process uncovers practical information for managing the functions of conciousness and using them to your advantage.

VISUAL JOURNAL EXERCISE

PART 1: Mapping Your Modes of Functioning

1. Turn to a blank page spread in your journal. On the left page, make a column with the heading Constructive Thinking. On the opposite page, make a column titled Destructive Thinking. Take five or ten minutes to quickly list all of the ways you experience the thinking function.

2. Next, turn to a blank page for writing your responses to the journaling prompts on the right.

3. Now, either on new pages or working directly over your journaling prompt writing, create a visual representation of your thinking function at its best. What constructive qualities of your thinking function inspire you to be your best and help you do your best work?

4. Repeat this entire exercise for the feeling, acting, and sensing functions.

JOURNALING PROMPTS

- How do you experience the thinking function in your life and work?

- What constructive thinking functions do you use now? How?

- Which constructive manifestations of this function, if you consciously gave them more energy, would have the biggest impact on your life and work? How? What would that look like?

- What destructive aspects of thinking are at play in your life and work?

- What is the payoff for allowing those destructive aspects to continue to exist? How are they serving you now?

- Reducing which destructive aspect, even a little, would have the biggest positive impact on your life and work?

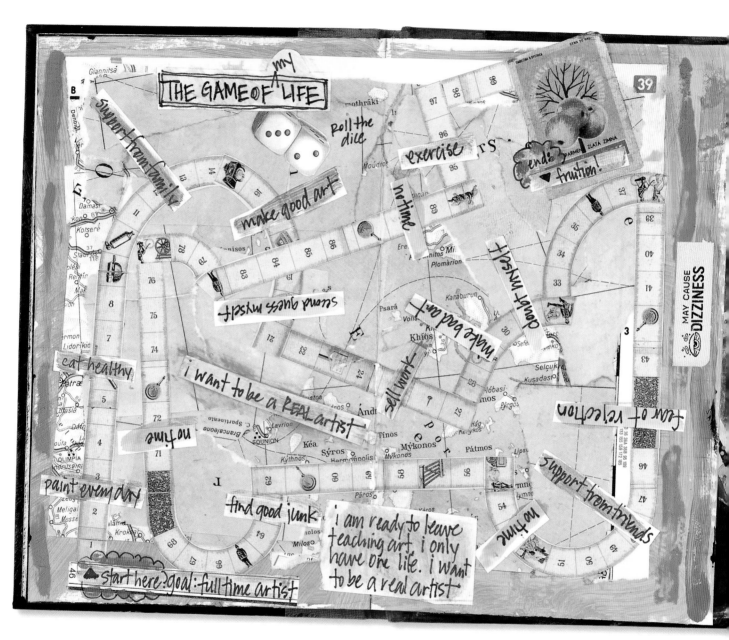

Constructive and destructive
aspects of thinking, feeling,
and acting show up on a
mock game board.

Ruth Fiege

PART 2:
Mapping Your Remedies

1. The thinking mode of functioning is used as an example. Turn to the thinking function page spread and add additional pages as flaps that open to either one or both sides. Use plain blank paper, decorative paper, or the pages from your journal prompts as a background.

2. Document with word and image what you need to know about nurturing the constructive thinking function in yourself. Just making a list is fine, if you don't have an image. What is already supporting your constructive thinking that you want to keep doing? What new remedies do you want to try? *Remember that the remedy for destructive thinking function is found in the constructive feeling and acting functions.*

3. Map your remedies for the feeling and action modes of functioning page spreads by using the same journal prompt questions as on page 58.

The remedy for any destructive aspect of a function is always found in one of the constructive creativity areas of the other functions. See the columns for ideas, or refer to your own constructive aspects list under each function.

- *Destructive thinking is...*
 remedied through constructive feeling and action.
- *Destructive feeling is...*
 remedied through constructive thinking and action.
- *Destructive action is...*
 remedied through constructive thinking and feeling.

Remedies for destructive thinking, feeling, and acting are written on pullout tabs.

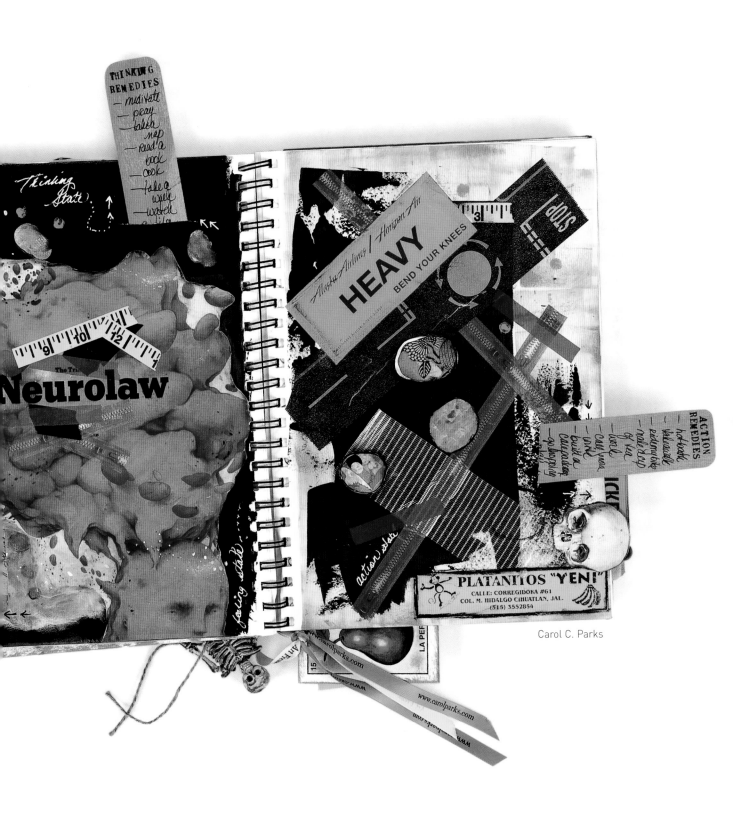

Carol C. Parks

Mastering Your Modes: Recipe Cards

It's important to plan ahead for times of low energy or when one of the destructive aspects of thinking, feeling, or action crops up. It happens to everyone who does creative work, so these recipe cards will ensure you are prepared. Next time you hit a rough patch of bad thinking, moody blues, or lethargic nonaction, you'll have some inspirational recipes to get you back on track.

Each card will depict one of your challenges, and on the back of each will be a list of remedies you respond to. Just think: the more challenges, the more cool cards you'll have! You can make copies and swap with other creative entrepreneurs if you like.

1. In your journal, use the left page of the spread to depict something you are struggling with in one of the modalities of thinking, feeling, or action.

2. On the right page, make a picture of your remedy for that situation. If you have several remedies, make a list. Remember, these will be shrunk down to card size, so keep that in mind, especially with words; you want to be able to read them at a reduced size.

3. Now make a scan or copy of each page and shrink down to the size card you want. Good sizes are 4" by 6" or 5" by 7".

4. Set up a master printing sheet to fill up a whole page. Print the front and back on separate sheets.

5. Trim cards to size and then glue together.

6. Embellish with glitter or other ephemera. A nice touch is to go around the edge of the card with a metallic or colored marker.

IMAGING TIPS

- Play with themes: Give each of the modes of functioning a different border or design element, just like a suit of cards would have. Get inspiration from tarot card decks.

- Do you like vintage ephemera? Try making characters out of old photos or illustrations of people from another era.

- Go abstract: Scribble. Doodle. Rant. No reason your image can't be a close-up of a journal entry.

- Funky self-portraits: Take some funny/moody pictures of yourself or an environmental shot that expresses the destructive pitfall. This is a lovely way to recycle poor photos. Alter and paint and doodle on the images.

- Make a cartoon: We all need a caricature of ourselves not at our best. Go ahead and exaggerate your worst feature.

- Go digital: Take a self-portrait using your digital camera or the built-in camera on your computer. It's easy to turn the photo into a line drawing, posterize it, or add other effects using photo editing software.

Artist L. K. Ludwig uses self-portraits and her own photographs as the basis for her Mastering Your Modes Recipe Cards.

L. K. Ludwig

Nature-inspired recipes for mastering destructive modes of thinking, feeling, and acting.

Ideas for creative card storage:

- Decorate or alter an old recipe box.

- Find a cigar box that's a size you like, and create larger cards to fit inside.

- Decorate envelopes and tuck a few cards inside. Don't forget to mail some to your support network or other creative entrepreneurs.

Remember, you want to keep them handy for when you're feeling stuck.

Barbara C. Bourassa

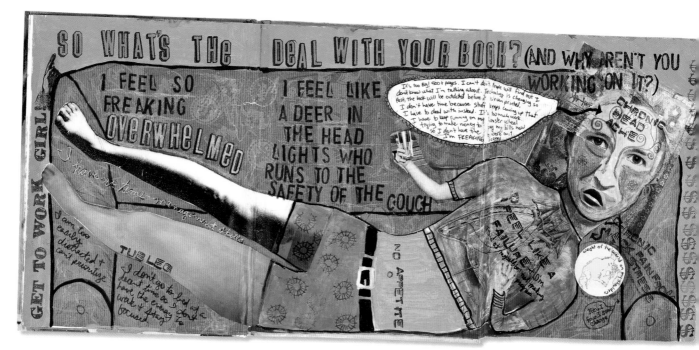

Traci Bunkers

Self-Inquiry Portraits

In this exercise, two self-inquiry portraits are created: one that portrays your experience with the destructive aspects of the four modes of functioning, and one that portrays your experience (or desired experience) with the constructive aspects.

Consider your relationship to thinking, feeling, acting, sensing regarding a specific creative project or idea. How do you experience these modalities in your approach to your work?

1. Turn to a new two-page spread in your journal. For a larger space, add more paper to each page, if needed. Draw an outline of yourself on the page. Turn your book vertical if your portrait is standing, horizontal if reclining.

2. Add background texture to the pages with random papers from your stash. Try mixing decorative papers with junk mail, wrapping paper, old maps, or pages torn from books or from your own journals.

3. Accepting that 99.99 percent of us are not portrait artists, go ahead and draw, paint, collage a self-portrait of your entire body. If you are a portrait artist, try this using nothing but papers out of your recycling bin and the art supplies available at the drugstore.

4. Once you've got an image of yourself on the page, see if you want to bring out any background elements or if you want to add elements to create a setting. Where are you? What are you doing?

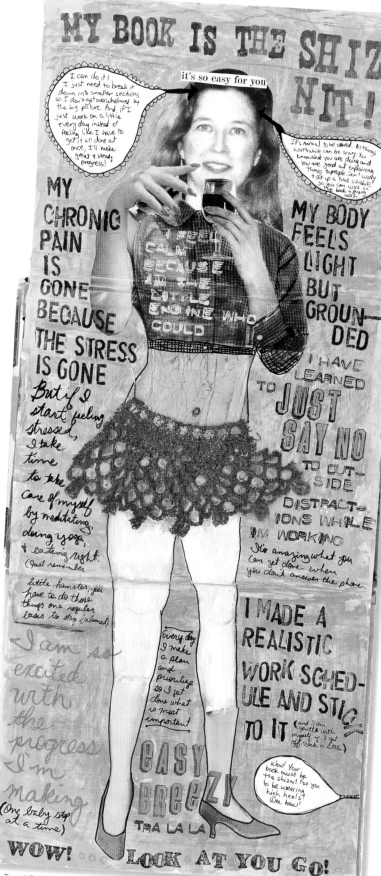

Traci Bunkers

Self-inquiry portraits are a fun way to explore and visualize the destructive and constructive aspects of the four modes of functioning. The outcome of the portraits is as unique as each individual's experience of these aspects in their work and life.

"The greater the tension, the greater is the potential. Great energy springs from a correspondingly great tension of opposites."

—Carl Jung

LEFT

A painter's self-inquiry portrait reveals the destructive aspects of her thinking function, clearly illuminating the negative self-talk that has previously derailed her progress.

RIGHT

The constructive aspects of the same painter's thinking and action function show the personal and professional breakthroughs in step two of the self-inquiry portrait journal exercise.

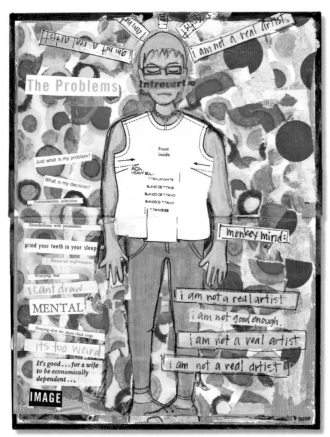

Ruth Fiege

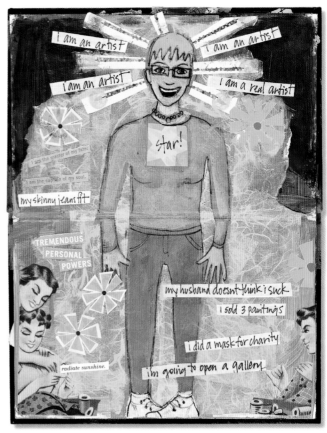

Ruth Fiege

5. Think about the journaling prompts on the next page and write down your responses directly on your self-portrait. Write all over the page. If you produce more writing than will fit on the page, keep writing on a separate page.

6. Use the insights and momentum gained from whichever self portrait you did first (constructive or destructive) to dive into the next one. Make sure you do both self portraits.

7. Now give each of these self portraits a title.

8. Do some journaling about what you learned from this process. What will you do with this information? How can you use this insight to begin/or continue doing your work?

- THINKING: What's in your head? What kind of thoughts are you having?

- What things you are telling yourself?

- Examples of destructive thinking: Maybe this idea is just too hard. I've had lots of ideas, but nothing ever comes of them. It takes time and money to start this venture, and I don't have it. Maybe I should just stop kidding myself.

- Examples of constructive thinking: I can use the 90 percent of my mind that is not normally tapped by learning some new, constructive thinking scripts, like, So what if I'm stuck? This is a normal part of the process.

- FEELING: What's in your heart? How are you feeling? I feel angry. Happy. Sad. Elated. Frustrated. Focused. Hopeful. Distracted. Overwhelmed. I feel like a big piece of garbage because.... I feel like a failure because.... I feel inspired because.... I feel calm when....

- SENSING: How do you experience the thoughts and feelings in your body? Describe the sensations as if you are simply reporting them to a doctor. There is a weight pushing on my shoulders. My throat is dry. My breathing is shallow. My heart is beating fast. My intestines feel like they are turned inside out. My head is clear. My heart feels expansive, like it is bursting with happiness. My spine is tingling.

- ACTING: What are you doing—or not doing? I'm not writing my screenplay or business plan. I didn't get to the studio because I watched TV for five hours. I went to the studio, but I stared into space. I researched procrastination on the Internet instead of working. I felt exhausted but, instead of getting horizontal, I went for a hike. I ate well today and felt much more focused. I drank more water instead of coffee and had more energy.

IMAGING TIPS

- Remember, this is your journal and you can tell the truth.

- The more specific and honest you can be, the more creative juice you'll get. Think of this process as a way to access your own inner energy elixir.

- Be generous with humor and self-compassion as you work on this. Remember, the essence of who you really are—that is, the creative genius part of you that is inspired to put your work into the world—is hanging out underneath the little dramas.

- You are not making art; you are inquiring about significant matters using art supplies. If you keep forgetting this is not art, give yourself permission to make the worst images that ever existed in the history of the world. Then try to make them even worse.

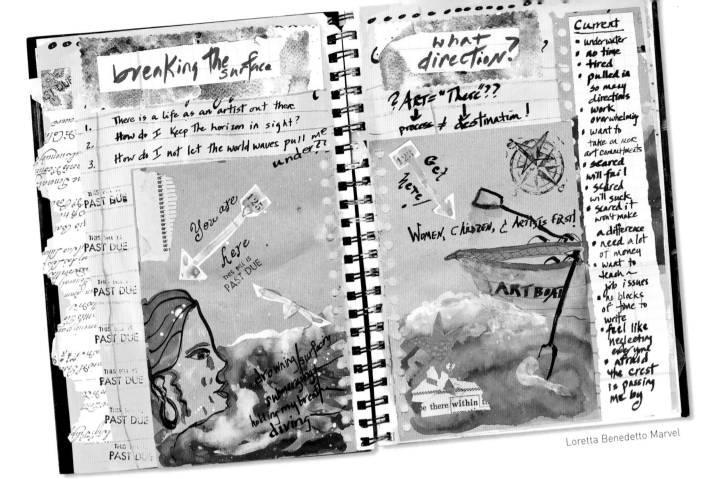

Loretta Benedetto Marvel

TOP

This creative entrepreneur's structural tension map emerged as a visual metaphor of water themes that helped clarify where and how being stuck and not moving forward is experienced.

BOTTOM

An art teacher maps out the structural tension experienced as she establishes herself as an exhibiting and selling painter.

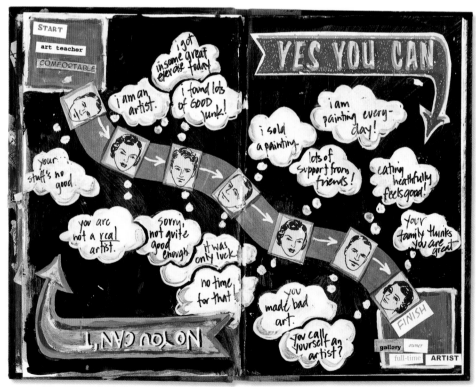

Ruth Fiege

Structural Tension

You know how it feels when you have decided you want a certain outcome but you are still living with things as they are before the desired change? You've decide you are going to work in your studio x number of days, but you just can't seem to get in there. Or you've been given this big break (to write a book, or exhibit your work at a major gallery, or teach your creative technique on television), but you are struggling through the daily tasks of making it happen. Instead of feeling enthusiastic and happy, you're anxious and worried and probably beating yourself up on top of it. This is especially prevalent in creative work, because making something new that is important to us is always work of the heart and spirit. Our emotions are involved. A lot is at stake for us.

This new opportunity we are moving toward sets up an inner conflict between where we are and where we want to be. If that conflict becomes intolerable, we relieve the pressure either by lowering our standards or by abandoning the goal altogether.

This isn't because we are weak, or unfocused, or lacking in some way. It's because we don't understand a key component in the process of achieving goals: structural tension. Feeling the pain of the difference between where we are right now and where we want to be is called *structural tension*. Being able to tolerate structural tension is a major key to accomplishing what we want.

The following exercises will help you work with structural tension in two ways. The first is creating a map of what structural tension looks like for you. Essentially, you are mapping the potholes in your road so you don't hit them, or if you do hit them, you aren't thrown entirely off course. The second exercise is for wrestling with structural tension creatively when it arises. Sometimes, just having a name for what you are experiencing can give relief. "Oh, here I am wanting my creative dream to be here now, and it's not. What I'm feeling is structural tension." Cool, huh? If that doesn't do it, fine. That's what your visual journal is for.

> "Take your practiced powers and stretch them out until they span the chasm between two contradictions."
>
> —Rainer Maria Rilke

Documenting Structural Tension

1. Mapping Out the Potholes in the Road

When you want to map out the things you are worried will interfere with reaching your goal, try these techniques:

- On one side of a journal page, depict your current reality. What does it look or feel like? You might even label it "you are here," like on a wayfinding map.

- Next, across the page, depict your desired outcome from accomplishing your goal. Give it its own label.

- Journal about what sorts of things usually happen to derail your progress. What are you afraid will happen? (Ideas: getting sick, getting stuck and not finishing, putting off starting, being distracted by x, falling into a destructive habit, etc.)

- Create a map of the space between where you are now and where you want to be. Sketch in or write down those potential pitfalls. It could look like a street map, a floor plan, even a child's game board. Whatever kind of map you are drawn to is perfect.

- Now, imagine some rest stops or refueling stations along the route. They hold the ingredients necessary to remedy those pitfalls and keep you going on your journey. What are those things for you? Walks in nature? More rest? Turning off the phone? Limiting TV? Praying? Meditating? What restores your balance and keeps you in the game?

2. Getting Back on Track

When you are experiencing structural tension, try this: Get the conflict out on paper. Do a visual journal page about what it feels like to be where you are right now compared to where you want to be. If it feels messy, make the page messy. Remember, a visual journal is a journal first. You are not making art. See if you can even exaggerate the feelings on the page. How frustrated, ugly, messy can the page look? What does this conflict feel like, look like? How does it manifest in your life? What does it say to you? What do you say to yourself? Use both writing and image to get it all down in your journal. Take notes about what you experienced after the process. What insights came to light? Was there a shift in emotion? What was the experience like?

OPPOSITE TOP
Spontaneous journaling and one-minute self-portraits on pages from the *Wall Street Journal*, done during a tense moment in the office.

OPPOSITE BOTTOM
A three-page spread maps out structural tension. The middle panel explores contributing factors.

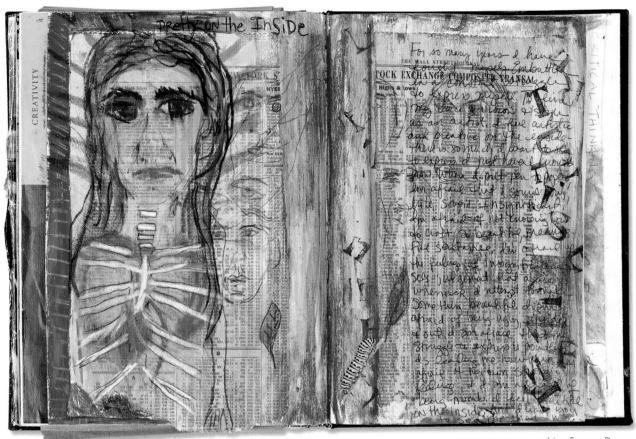

Lisa Sonora Beam

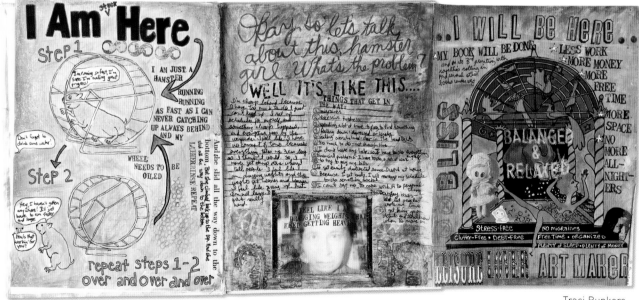

Traci Bunkers

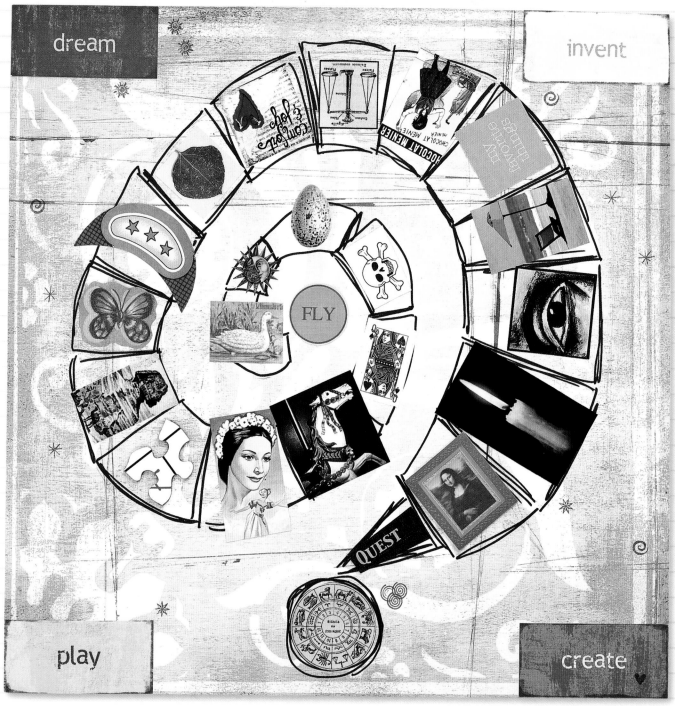

dream

invent

play

create

Paule Merlin

The Art of Strategy:

Thinking Like a CEO

4

THE ART OF STRATEGY PROVIDES A FRAMEWORK for determining the results you want to achieve, a workable plan for making it happen, and a way to regularly monitor progress and make adjustments as you go. This is called *strategic planning*. While it does take time and careful consideration to create a strategic plan, not having one costs far more in lost time, mismanaged resources, and the frustrations and stress caused by a lack of planning. This chapter guides you through the process of creating strategic plans that can be used both personally and professionally.

"Your vision of where or who you want to be is the greatest asset you have. Without having a goal, it's difficult to score."

—Paul Arden

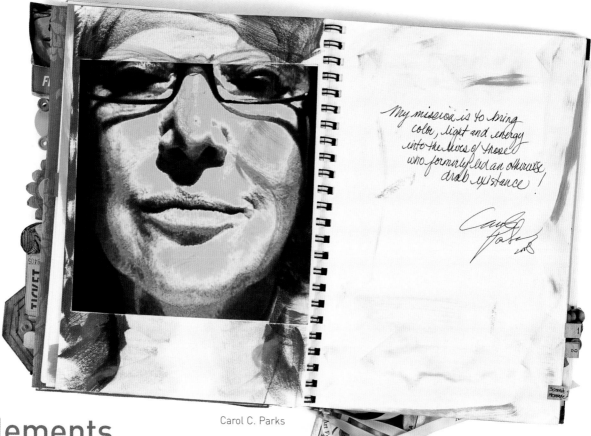

My mission is to bring color, light and energy into the lives of those who formerly led an otherwise drab existence!

Carol C. Parks

The purpose or mission of your business is fine-tuned in the strategic planning process.

Elements of the Strategic Planning Process

Creating a strategic plan involves

1. Considering the purpose for your business

2. Analysis of your business opportunity and the competitive landscape (SWOT analysis)

3. Researching unknown variables identified in SWOT, minimizing weaknesses, and capitalizing on strengths

4. Determining the outcomes desired for the business in the next twelve to eighteen months

5. Creating SMART objectives, strategies, and tactics

6. Organizing the objectives, strategies, and tactics into a calendar with timeline, budget, party responsible and tracking plan in place

7. Consistent monitoring of progress and documentation of results

8. Refining the strategic plan as needed

Without a strategic plan, it's easy to end up going in a bunch of different directions. Urgent matters not related to your goal take precedence (putting out fires). When the going gets tough, the big picture can be overwhelming. The strategic plan breaks down your goal into doable chunks. You are able to feel a sense of accomplishment every day, even when things get stressful. This helps you maintain your momentum and stick to your plan.

The pressures of multitasking, the fast pace of life, and the ever-changing business landscape mean we have to make decisions quickly, in the moment. Having a strategic plan in place helps you

- Decide what objectives are the most important within the next year or so

- Make decisions on the fly that are in alignment with your desired outcome

- Decide how best to use your resources (time, money, projects) based on your chosen objectives

- Communicate the overall plan to others who may need to know (family, employees, investors, suppliers, etc.)

- Easily evaluate the opportunity cost of opportunities that come your way

- Make day-to-day decisions with a firm idea of how those choices will take you closer to or further from your goal

- Stay on track when you hit potholes or when opportunities arise that are different than what you have decided is most important to you

- Have measurable outcomes that allow you to track your progress

- Step out past the competition. If you take the time to do strategic planning well, you will set yourself apart—lots of well-meaning and talented enterprises fail due to lack of planning

- Most importantly: A strategic plan will help you evaluate whether or not your plan of action currently is working for you

It does takes *time* and *analytical thinking* to plan. But spending time this way is an investment. You get back more than you put in. All successful businesses devote a significant amount of time to strategic planning. Those that don't, suffer from many preventable problems that could ultimately cause them to go out of business.

STRATEGIC

- Has a plan to accomplish short-term and long-term objectives that is monitored and adapted
- Sees the big picture
- Sees patterns and how they relate
- Has a process for dealing with uncertainties
- Gathers facts, feedback, information from many sources

NOT STRATEGIC

- Does not have any plan
- Puts out fires of the moment
- Reacts to circumstances rather than plans proactively
- Ignores uncertainties
- Has only a vague idea of what success looks like
- Faces constantly moving targets

The Purpose of Your Business

The exercises in chapter 2 will help you extract the overall purpose of your business. Fine-tune your purpose with these questions:

JOURNALING PROMPTS

- The business opportunity I want to explore/create is:
- It utilizes my unique gifts by:
- The clients I intend to serve are:
- It provides value to my customers by:
- If you are working with others, be sure everyone is aware of and on board with your overall purpose and intention.

SWOT Analysis

SWOT is an acronym for strengths, weaknesses, opportunities, and threats. Analyzing these four factors gives a clear picture of the trends in the marketplace you can capitalize on, and potential threats to minimize, while considering the internal strengths and weakness of your business.

The SWOT analysis provides a snapshot of your business within the current market situation. Once you craft your SWOT, you can use it to determine what areas of your idea need to be researched, strengthened, or changed.

The four SWOT factors are divided into two parts, internal and external. *Internal* means within your control; *external* means outside of your control.

Strengths and weakness are internal to your organization. Things within your control include credit rating, access to collateral, skills and experience related to your business. In a SWOT analysis, something cannot be both a strength and a weakness.

Opportunities and threats are external to you or your business, meaning they are not within your control. External factors include existing in a global marketplace, technological developments, Internet speed, interest rates, cost of fuel, and supplier operations.

Thinking about opportunities and threats can seem daunting, so use this additional acronym to help you

SWOT is an acronym for strengths, weaknesses, opportunities, and threats.

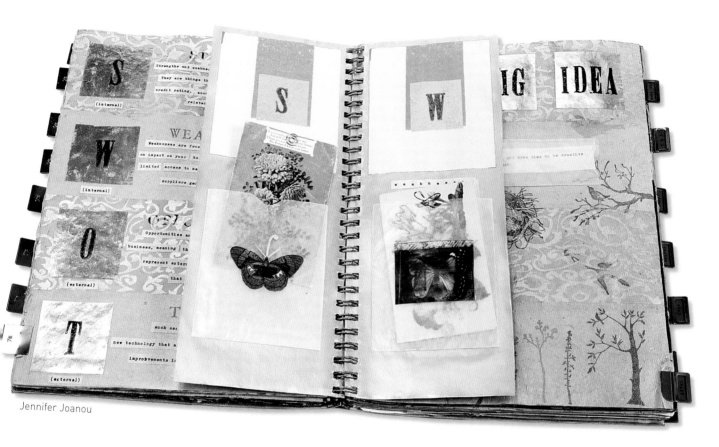

The artist's style of working is carried throughout her vividly illustrated Creative Entrepreneur Journal. The process of creating the journal with such care and attention to detail allowed the artist to contemplate her business ideas in ways that felt supportive and meaningful. The strengths/weaknesses section of her SWOT analysis is shown here.

Jennifer Joanou

brainstorm: STEEP-C, which stands for the social, technological, environmental, economic, and political factors that can affect your business. The *C* stands for competitive. A thorough analysis of opportunities and threats must always include a look at what your competitors are doing. Considering the STEEP-C factors helps in developing business strategies that anticipate new demands and minimize potential risks. Not every business is affected by every STEEP-C factor, but it's good to look at each category during the brainstorming process.

When to SWOT

1. Whenever you are creating a new business.

2. For each new product or service you add to your business.

For existing businesses, it's good practice to revisit and update the SWOT annually or whenever your business or the marketplace affecting your business is in transition. This will help you be attuned to new opportunities and threats.

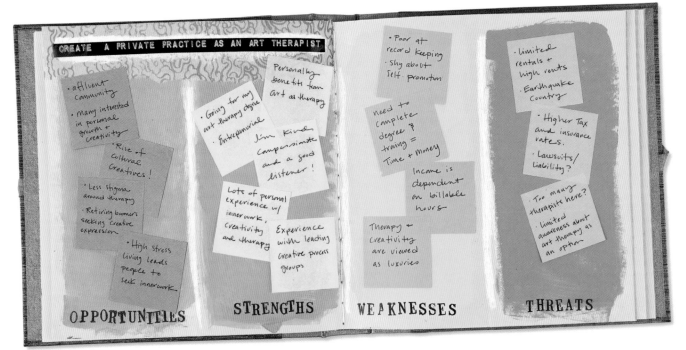

CREATE A PRIVATE PRACTICE AS AN ART THERAPIST

OPPORTUNITIES

• affluent community
• Many interested in personal growth + creativity
• Rise of cultural creatives!
• Less stigma around therapy
• Retiring boomers seeking creative expression
• High stress living leads people to seek innerwork

STRENGTHS

• Going for my art therapy degree
• Entrepreneurial
• Personally benefits from art as therapy
• I'm kind, compassionate and a good listener!
• Lots of personal experience w/ inner work, creativity and therapy
• Experience with leading creative process groups

WEAKNESSES

• Poor at record keeping
• Shy about self-promotion
• Need to complete degree & training = Time + money
• Income is dependent on billable hours
• Therapy & creativity are viewed as luxuries

THREATS

• limited rentals + high rents
• Earthquake country
• Higher Tax and insurance rates.
• Lawsuits/ liability?
• Too many therapists here?
• limited awareness about art therapy as an option

Annie Danberg

SWOT factors are brainstormed first on separate sticky notes, then placed in the appropriate categories for quick analysis.

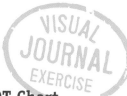

How to Create a SWOT Chart

1. In your journal, write down the idea you are exploring across the top of a full-page spread.

2. Make four columns across the spread in this order: Opportunities, Strengths, Weaknesses, and Threats. Remember that Strengths and Weakness are internal to your business, so it's helpful to keep those next to each other in the inner columns. Opportunities and threats are external, so list them in the outer columns.

3. List the STEEP-C grid categories along each side of the outer columns of Opportunities and Threats. Having these categories in place will help you think about opportunities and threats more broadly. STEEP-C categories: Social, Technological, Environmental, Economic, Political, and Competitive.

4. Now you're ready to brainstorm all the items you can think of for each category. After you've filled in each list, take your SWOT to others for feedback. They will likely have other ideas you haven't thought of.

How to Use the SWOT Chart

The most important thing about the SWOT is to use the information in the chart to help shape your business strategy. The completed SWOT will show you a clear picture of potential opportunities and help you with the next step, which is learning which areas of your idea need more research. Ultimately, the purpose of the SWOT is to minimize the largest potential threats to your business and capitalize on the strongest opportunities by continuing to develop your strengths and remedying the most vulnerable weaknesses.

- What opportunities related to my business idea are present in the marketplace that I haven't considered?

- What is the one opportunity I can pursue now and expect the most results from?

- What opportunities do my competitors seem to be capitalizing on?

- What opportunities can my business meet better than my competition? Why? How?

- What are the other two or three opportunities that back up my plan of action?

- Of the potential threats identified, what are the top one to three threats related to my business that could affect it most significantly? How?

- What safeguards do I have in place to minimize those threats?

- What might the worst-case scenario look like?

- Of all the strengths listed, which contribute directly to my competitive advantage?

- Which strengths create value for my customers?

- How does this value translate into goods/services offered?

- What do I perceive to be the number-one weakness?

- With the resources I have now, how can I best mitigate that weakness?

- What measurements can I use to determine if the weakness is being successfully minimized or eradicated?

- What other weaknesses need immediate attention in order to give my plan the best chance at success?

- What is the action plan for dealing with those weaknesses?

An overview of what the SWOT analysis is, and how to do it, is crafted artfully out of the notes the artist took at the Creative Entrepreneur workshop.

STRENGTHS

Strengths and weakness are internal to your organization or idea. They are things that are within your control, such as: credit rating, access to collateral, skills and experience related to your business or idea.

(internal)

WEAKNESSES

Weaknesses are forces beyond your control, which can have an impact on your business. Things like rising costs of fuel, limited access to materials needed to manufacture your product, suppliers going out of business or selling.

(internal)

OPPORTUNITIES

Opportunities and threats are external to you or your business, meaning they are not within your control. Opportunities represent external conditions in the marketplace that you want to capitalize on.

(external)

THREATS

such as: existing in a global market place, new technology that allows for quick manufacture in low quantities, improvements in internet speed, lower interest rates.

(external)

Jennifer Joanou

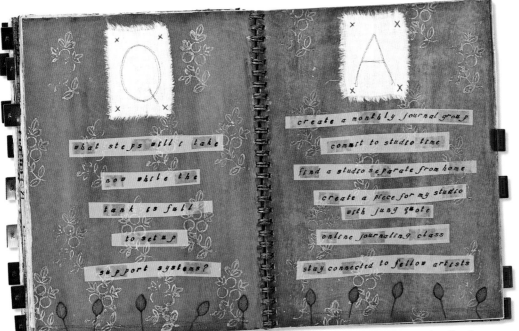

The handwritten text in the image reads:

Q

what steps will i take

now while the

tank is full

to set up

support systems?

A

create a monthly journal group

commit to studio time

find a studio separate from home

create a piece for my studio
with jung quote

online journaling class

stay connected to fellow artists

TOP
After completing the SWOT, several ideas for further research were revealed.

BOTTOM
Layers of list-making and collage lead to areas that require further research or concrete action steps. Adding visual elements and doodling helps loosen up the thought process to get beyond limiting ideas.

Jennifer Joanou

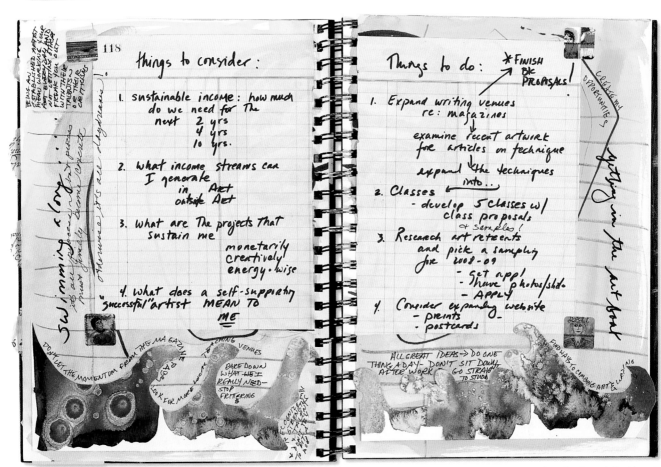

things to consider:

1. sustainable income: how much
 do we need for the
 next 2 yrs
 4 yrs
 10 yrs.

2. what income streams can
 I generate
 in Art
 outside Art

3. what are the projects that
 sustain me
 monetarily
 creatively
 energy-wise

4. what does a self-supporting
 "successful" artist MEAN TO
 ME

Things to do: *FINISH BK PROPOSALS!

1. Expand writing venues
 re: magazines

 examine recent artwork
 for articles on technique

 expand the techniques
 into...

2. Classes
 - develop 5 classes w/
 class proposals
 & samples!

3. Research art retreats
 and pick a sampling
 for 2008-09
 - get appl
 - have photos/slds
 - APPLY

4. Consider expanding website
 - prints
 - postcards

ALL GREAT IDEAS → DO ONE
THING A DAY - DON'T SIT DOWN
AFTER WORK GO STRAIGHT
 TO STUDIO

Loretta Benedetto Marvel

Research:
Taming Wild Guesses, Intuitions, and Assumptions into Facts and Certainties

Anxiety about a new business is often due to lack of certainty. The research process helps take away uncertainty by removing blind assumptions.

The purpose of research is to check out all of the assumptions you have about your idea to determine how true or false they are. The goal is to reduce your level of uncertainty about how your idea may play out. Obviously, you cannot be 100 percent certain about all that might occur in the future related to your business idea. The goal is not 100 percent certainty but, rather, finding a level of certainty you and your stakeholders are comfortable with in order to proceed. Research reveals your areas of risk, so you can minimize the largest threats and take advantage of the biggest opportunities. The fact is, unforeseen events happen that affect us positively and negatively. An astute businessperson has already imagined what those events might be and has investigated what the potential impacts are. This is part of the art of strategy. It's the chess player who is thinking several moves ahead. Or, as one of my business school teachers put it, it's knowing where the potholes are in the road ahead before you fall into them.

Creating a Research Punch List

VISUAL JOURNAL EXERCISE

1. Review your completed SWOT and circle all the items that are critical to your business.

2. On a scale of 1 to 10, rank these items according to your level of certainty about how true they are, with one being not certain at all and ten being absolutely certain. Anything with a rating of seven or less probably warrants research. Make a fresh list of these items in your journal.

3. Determine a plan of action for raising your certainty to 7 or above. Decide how you will research your assumptions. Check with experts in your field, trade associations, manufacturers, clients, associates, and publications, and search the Internet.

4. Keep track of your findings in your journal.

Make Your Desired Outcome Real: Objectives, Strategies, and Tactics

Once you've analyzed and researched the opportunity you are considering, the next step is to determine the outcome you want to achieve. It's not enough to simply set a goal. This is where most targets fail to be hit. The difference between entrepreneurs who get great results and those who don't has to do with *how* the goal is set. The secret lies in a three-step process: 1. Creating SMART objectives, 2. Making sure they are supported by carefully considered strategies, and 3. Executing strategies with precise tactics.

Definitions:

Objective: What you decide to achieve

Strategies: How to plan to achieve

Tactics: The action steps required to fulfill each strategy.

Why Goal-setting Often Fails

The reason we don't achieve the goals we set is not because of lack of talent, intelligence, discipline, or motivation. There are three main reasons why goal-setting usually fails:

1. The objective is not structured correctly. The most likely reason is an error in how your goal was crafted. Using the SMART criteria to set an objective ensures the goal you are setting has the best chance of becoming real.

2. The objective is not aligned with your values and sense of purpose or conflicts with another objective. Without a values connection, even a SMART objective quickly becomes something tossed away when conflict or structural tension is experienced.

3. Failure to write down the objectives and to follow through with monitoring their progress.

TOP

Creating a visual model of a SWOT diagram helps to bring in aspects of play and nonlinear thinking that help explore business challenges and opportunities in empowering, rather than tedious, ways.

BOTTOM

Brainstorm ideas about what you want to create, then extract objectives out of what you want to do in the next twelve to eighteen months.

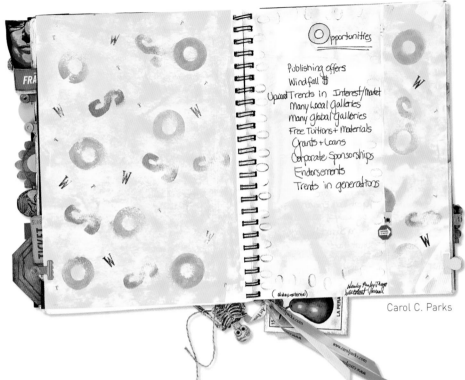

Carol C. Parks

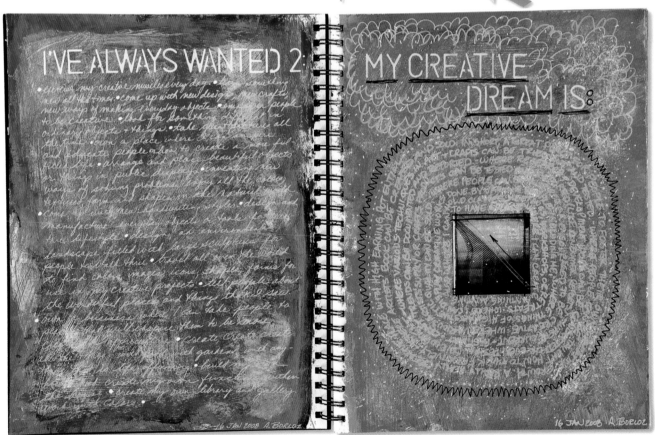

Andrew Borloz

Creating SMART Objectives

SMART is an acronym to help you remember the criteria of an effective objective: specific, measurable, achievable, relevant, timebound. If all of these criteria are in place, the objective is strong and can be easily communicated and acted upon by others, not just by the author of the objective.

Use the SMART acronym to evaluate and fine-tune each of the objectives in your strategic plan.

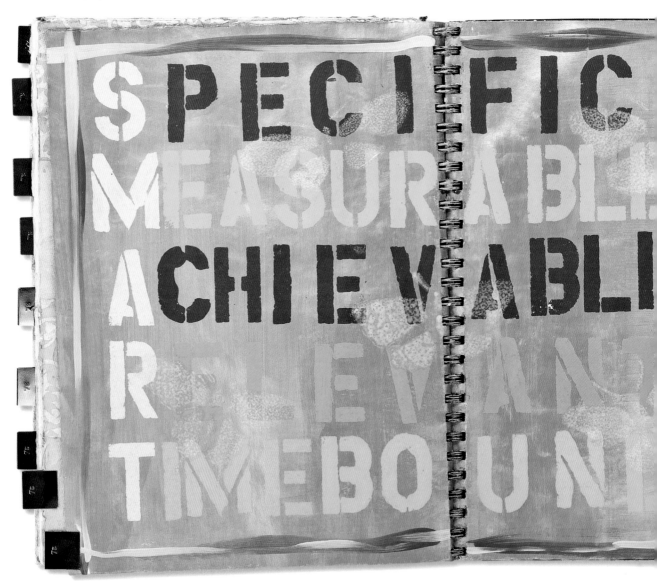

SPECIFIC

Criteria such as frequency, rate, or percentage set for a specific outcome. "Expand product line" is open to interpretation. "Launch one new product line per year, consisting of three items with four color variations each" is specific. Questions to ask: What specifically will the outcome for this objective look like? Could someone who did not set the objective gauge its success or failure? Specificity takes subjectivity out of the equation.

MEASURABLE

The way to measure the specific objective. Devise a system for tracking progress on the objective. Decide how, who, when, and where the objective will be measured and reported on. Questions to ask: How will I know for certain I am making progress on the objective? How would someone else know? For example, if you have employees, how will they know they are successfully meeting the objective or not? What quantifiable measures (number, frequency, percentage, time) are in place to track the objective?

ACHIEVABLE

Given available resources (such as time, money, help), how achievable is the objective? Questions to ask: What resources must be in place to support this objective? Is it reasonable to expect these resources are available at this time? Do I have capabilities required to accomplish this objective within the timeframe set?

RELEVANT

How is the objective meaningful to the person assigned to execute it and to the company in general? Questions to ask: For what purpose am I taking on this objective? Will the achievement of this objective positively affect quality of life and/or business in significant ways? How is this objective aligned with what I value most?

TIMEBOUND

This is putting a timeline on the objective. Question to ask: By what date will this objective be completed? Without a deadline, an objective becomes a moving target that cannot be hit.

Jennifer Joanou

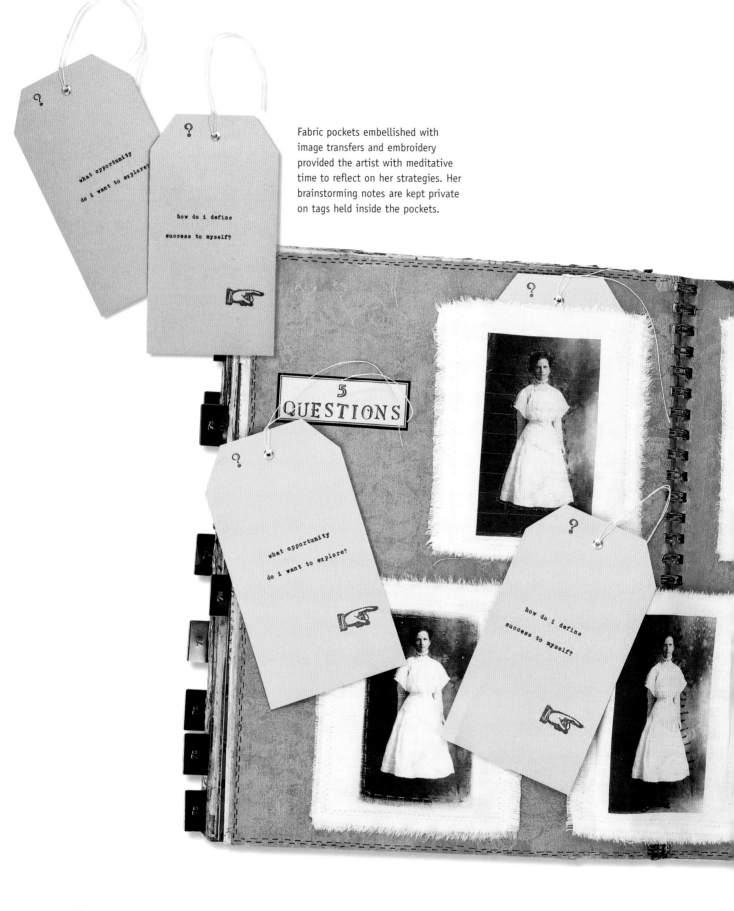

Fabric pockets embellished with image transfers and embroidery provided the artist with meditative time to reflect on her strategies. Her brainstorming notes are kept private on tags held inside the pockets.

?
what opportunity
do i want to explore?

?
how do i define
success to myself?

5
QUESTIONS

?
what opportunity
do i want to explore?

?
how do i define
success to myself?

Develop Strategies for Each Objective

A strategy is how you're going to achieve the objective. Most objectives have more than one strategy but usually no more than three or four. What strategies we choose depend on what resources, such as time, money, knowledge, staff, and suppliers, we have available

For example, if your objective is to have x dollars per year in income, one strategy is to ramp up sales of your product or service. Another strategy is to spend less. Yet another strategy is to earn money through investments or passive income streams. A strategy is how you intend to accomplish an objective. Sometimes it is helpful to brainstorm seemingly outlandish strategies to open up possibilities not previously imagined.

Tactics: To-Do Lists

Defining objectives and corresponding strategies is a planning activity. The next job is to get down to the action items: What exactly must be done to fulfill the strategies? A tactic must be in service to one of the strategies. Some of your tactics might overlap strategies. Your list of tactics can be thought of as short-term goals.

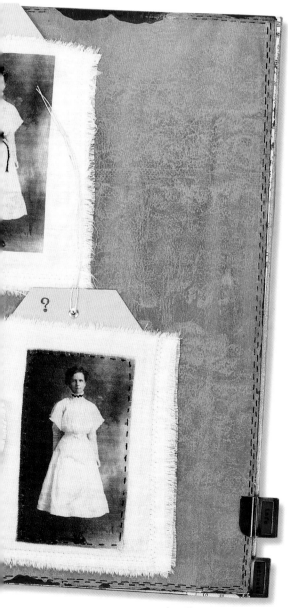

Jennifer Joanou

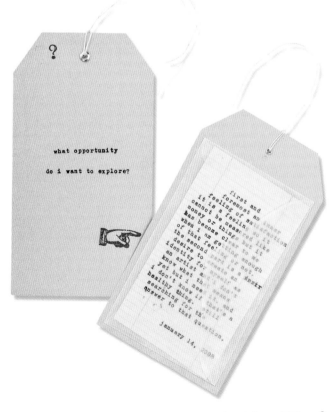

Brainstorming Objectives, Strategies, and Tactics

The easiest way to begin determining objectives, strategies, and tactics is simply brainstorming all of your ideas for what you want to accomplish in one place. Think of your list as something that must be sorted into outline form. Out of this list, you will group like ideas and sort them into the appropriate hierarchy.

The process of brainstorming strategies and tactics, shown, on the left page of the journal, results in clearly defined tactics associated with each strategy, shown on the tree.

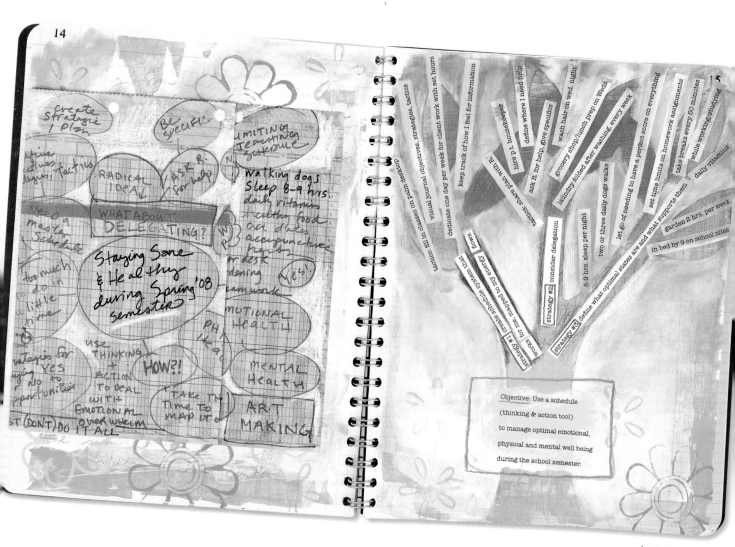

Annie Danberg

3 Steps to Creating Effective Objectives, Strategies, and Tactics

STEP 1: BRAINSTORM LIST

- Launch product line extension
- Update website
- Learn to blog
- Start an e-newsletter
- Organize and set up accounting system
- Research suppliers
- **Earn x dollars per year from creative business**
- Look into affiliate programs
- Partner with nonprofits
- Hire a rep
- Set up an online store
- License designs to major retailer
- Sell at kiosks during holidays
- Hire salespeople
- Research best malls
- Increase awareness of products to new customers
- Keep in touch with existing customers—referrals, what's new

STEP 2: SELECT AN OBJECTIVE FROM STEP 1 AND SORT THE REST OF THE ITEMS

OBJECTIVE:
Earn x dollars per year from creative business.

STRATEGY: Marketing

- Increase awareness of products to new customers
- Keep in touch with existing customers—referrals, what's new
- Tactic: Update website
- Tactic: Learn to blog
- Tactic: Start an e-newsletter

STRATEGY:
New Sales Channels

- Tactic: Hire a rep
- Tactic: Set up an online store

- Tactic: Sell at kiosks during holidays
- Research best malls
- Hire salespeople
- Tactic: Look into affiliate programs
- Tactic: Partner with nonprofits
- Tactic: License designs to major retailer

STRATEGY:
Product Development

- Tactic: Launch product line extension
- Tactic: Research suppliers

STEP 3: MAKE THE OBJECTIVE SMART MAKE STRATEGIES AND TACTICS MEASURABLE

SMART OBJECTIVE:
Generate 300,000 dollars in gross revenue from Bright Idea company by year three in business.

STRATEGY: Invest 15 percent of projected gross income in marketing to

1. Increase awareness of products to new customers (measured by number of hits to website, sign-ups to newsletter, requests for info, new customer orders).

2. Keep in touch with existing customers (measured by sending out six newsletters per year, attending five trade shows, doing twelve promotions).

 - Tactic: Update website
 - Tactic: Learn to blog
 - Tactic: Start an e-newsletter

STRATEGY: Increase sales by x% per year through multiple sales channels

 - Tactic: Seek representation in top craft market and hire a rep
 - Tactic: Set up an online store
 - Tactic: Sell at kiosks during holidays
 Research best malls
 Hire salespeople
 - Tactic: Look into affiliate programs
 - Tactic: Partner with nonprofits
 - Tactic: License designs to major retailer

STRATEGY: Develop one line extension per season to keep designs fresh and to offer clients something new, different, and improved.

 - Tactic: Launch product line extension
 - Tactic: Research additional suppliers

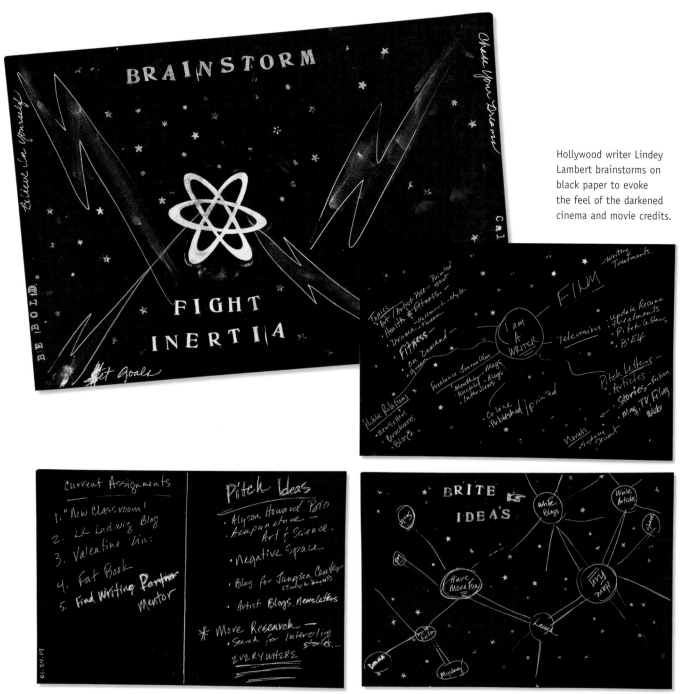

Hollywood writer Lindey Lambert brainstorms on black paper to evoke the feel of the darkened cinema and movie credits.

Lindey Lambert

"Put into your world what you wish were there."

—Pauline Rose Clance

Design Your Own SMART Framework

1. Decorate a full page with your favorite background technique.

2. Use a rubber stamp alphabet, stencils, or alphabet stickers to create the SMART acronym.

3. Write the questions from the grid for each segment in your own handwriting, using a favorite pen, paint, or crayon.

4. Leave a decorated blank space to record your answers. Take your journal to a copy shop and make color copies. Now you have a custom-made stack of SMART criteria worksheets you can use to quickly analyze any goal and turn it into a SMART objective.

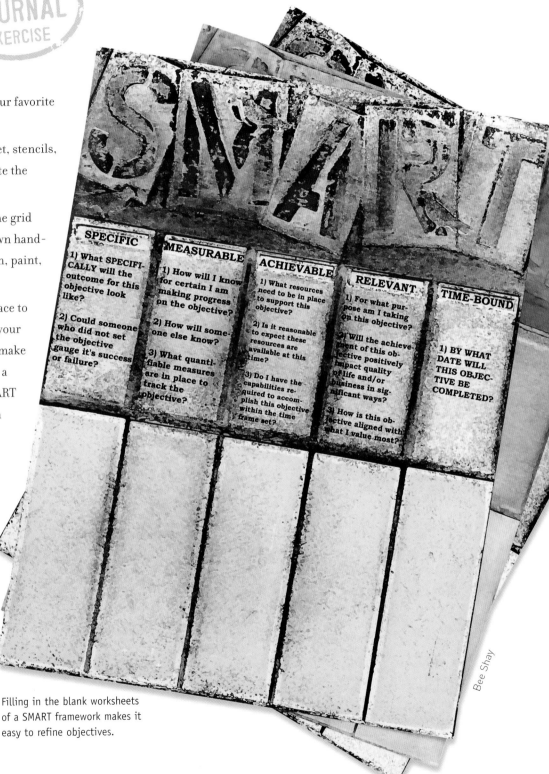

SPECIFIC

1) What SPECIFICALLY will the outcome for this objective look like?

2) Could someone who did not set the objective gauge it's success or failure?

MEASURABLE

1) How will I know for certain I am making progress on the objective?

2) How will someone else know?

3) What quantifiable measures are in place to track the objective?

ACHIEVABLE

1) What resources need to be in place to support this objective?

2) Is it reasonable to expect these resources are available at this time?

3) Do I have the capabilities required to accomplish this objective within the time frame set?

RELEVANT

1) For what purpose am I taking on this objective?

2) Will the achievement of this objective positively impact quality of life and/or business in significant ways?

3) How is this objective aligned with what I value most?

TIME-BOUND

1) BY WHAT DATE WILL THIS OBJECTIVE BE COMPLETED?

Bee Shay

Filling in the blank worksheets of a SMART framework makes it easy to refine objectives.

Pamela J. Lemme

SMART Objectives:
Envisioning Your Outcomes
with SMART Vision Cards

Now that you've written out SMART objectives, it's time to have fun creating a visual representation of your objective that you can use to stay motivated and inspired. Create a SMART vision card for each of your objectives.

1. Have your written SMART objective handy for reference.

2. Turn to a new two-page spread in your journal. The left page will be the front of the card; the right page will be the back.

3. From your stash—ephemera, magazines, and personal photos—gather images, words, phrases, colors, and moods that portray the realization of your objective.

4. Collage the elements on the left-hand page, keeping in mind that the purpose is to provide a visual cue of the outcome your completed objective will bring you. The collage may have a central focal image or an array of elements blended together.

5. On the right-hand page, create an area to write out the SMART objective. This page will be the back of the card.

6. Make reduced color copies of your pages—about 5½" by 8½". Make several copies for use in different projects and to hang up in your work area. Pages can also be scanned and then printed out on a laser or ink-jet printer. Glue the pages together, images facing out, to create a front and back card.

7. Optional: Laminate the cards with packing tape or a laminating machine, before or after embellishing with glitter, paint, stickers, and other items of your choice.

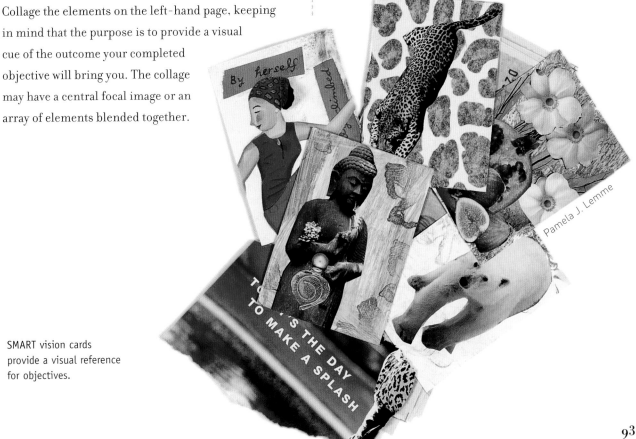

SMART vision cards provide a visual reference for objectives.

Pamela J. Lemme

Creating a Personal Strategic Plan

Now that you know how to use strategic planning for your business, it's very powerful to use this managerial tool in other areas of your life such as health, relationships, finances, creativity, and recreation. A personal strategic plan consists of creating objectives, strategies, and tactics to create the results you want and develop your leadership muscles as you achieve them.

1. Start by brainstorming a list of ideas about what you want to accomplish in the next year. Use the journaling prompts to help you hone in on what is most important to you.

2. From your brainstorm list, select an objective and look for ways to make it SMART (specific, measurable, achievable, relevant, timebound). Remember, an objective describes the outcome you want to achieve in ways that can be measured. Decide in advance how you will measure your progress and results so that you'll know if have accomplished your objective.

3. Develop your strategies and tactics: Strategies are how you will accomplish your objective. Tactics are the action items that fulfill the strategies. Measurements can also be put on tactics, and be treated as short term or ongoing goals. Making tactics measurable is a great way to track results daily, weekly, and monthly, so you can course-correct as you go.

4. Next, make SMART objectives out of two or three more things on your brainstorm list. I recommend no more than three to five main objectives for a year, otherwise the list of tactics can be daunting. Sometimes your tactics will overlap across objectives or strategies. In the example shown, hiking or biking with friends meets both objectives of being healthier and connecting with friends.

Motivation: Move Toward What You Want Rather Than Away From What You Don't Want

Make sure the motivation behind your objective propels you toward something you want rather than away from something you don't want. For example, if you set a financial goal, make sure you come up with a big list of compelling reasons why you want it that are positive and feel good to you. For example, I want x dollars per year so I can buy a house, go on a creativity retreat, and take my family on a long holiday. Not: Because I don't want to struggle financially, because I'm sick of being broke or living paycheck to paycheck. Can you feel the difference?

Objectives, Strategies, and Tactics

BRAINSTORM LIST
This Year's Objectives

- Create a budget
- Learn Spanish
- Travel more
- Be healthier
- Connect more with friends and family

OBJECTIVE

Be healthier. Achieve my best level of health and fitness so that I can do my best work and enjoy life to the fullest.

SMART measures:

- Goal weight of x pounds within twelve months
- Restful sleep every night
- No more migraine headaches

STRATEGY #1
Increase Physical Activity

Tactics:

- Hike four miles every week day
- Ride mountain bike for one hour, twice per week
- Yoga class three times per week

STRATEGY #2
Be Mindful of What I Eat

Tactics:

- Eliminate wheat, dairy, sugar, and meat
- Snack on fruit
- Have veggies at every meal
- Take supplements
- Drink eight glasses of water per day

STRATEGY #3
Reduce Stress

Tactics:

- Daily meditation
- Visit with friends/family 3-5 times week
- Don't watch television news
- Weekly art date
- Daily use of leadership tools

- What is the single thing that, if accomplished this year, would make the biggest difference in your life?
- What do you keep putting off and feeling bad about?
- What do you wish you could just cross off your list, once and for all?

The Strategic Planner

The strategic planner is a portable, easily updatable project organizer. Each objective has a separate section with corresponding strategies and tactics. Create one for both your personal strategic plan and the strategic plan for your business.

1. Choose an easy-to-update planner system with ring binders, disk binders, or an existing binder. Try making a strategic planner using a disk binding system or in a 6" by 9" three-ring notebook. As another alternative, recycle an existing planner: If you aren't using that expensive planner system, why not alter it? Repurpose the binder and tabs into your own strategic planner.

 Make your own book simply and easily using hole-punched card stock for covers and sections, index cards for pages, all held together with binder rings. If you do have a planner system you like with easily removed pages, consider adding a section for your strategic plan.

2. Create section dividers, using one for each objective. See the exercise for SMART vision cards (page 93) for ideas about visually representing your objective. If you have completed SMART vision cards, make copies to designate each objective section in your strategic planner.

3. Create tabbed sections behind each objective, one tab for each strategy. These can be made out of index cards the size of the pages. Make them colorful and inspiring with decorative papers, paints, and collage.

Lisa Sonora Beam

4. Place the tactics behind each strategy section. Build a master tactic list for each strategy or, if the tactics have a lot of to-do items, use one page per tactic. Remember, tactics are the action items associated with a particular strategy.

 Depending on your tactics, you will update these lists frequently as items are completed. Move the completed lists to a separate section, or store them in a card file.

Use your strategic planner! Don't let it languish on a shelf.

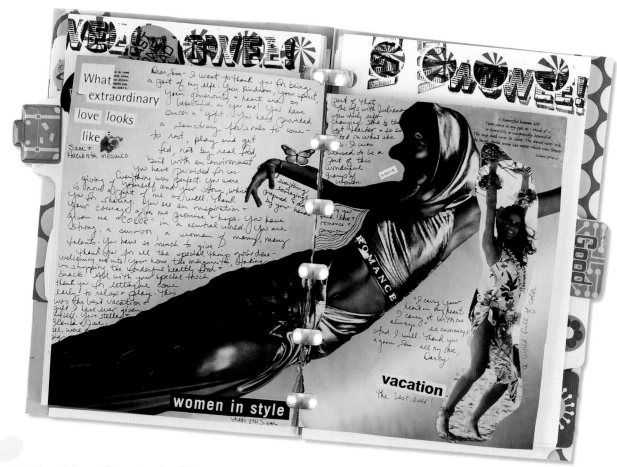

Darcy Ritzau

Ways to Use Your Strategic Planner

Track both personal and professional goals: If you are still formulating your business idea, use the strategic planner to create your own personal strategic plan. This is something I encourage my clients to do annually. Instead of New Year's resolutions, have a visual journal day with friends and make strategic planners using this chapter as a guideline.

- Stay inspired: Flip through the pages and consider your objectives. Remember your intentions and aspirations.

- Analyze opportunities: When considering adding an item to the to-do list or wondering whether or not to take on a new project, consider where it fits in the current set of strategies. What objective does it fulfill?

- Stay focused: Having your strategic planner in front of you diminishes the emotion and confusion surrounding decision making.

- Build momentum: Keeping your objectives in front of you in an inspiring way makes it easier to tackle the day-to-day tactics—especially on challenging days. The tactics are associated with a purpose: the fulfillment of an important objective.

- Make a stop-doing list: What sorts of things take up your time that don't fulfill any objective? Try making a stop-doing list. Of course you can't stop doing everything all at once, but this list will give you food for thought, and it will certainly help when considering what to add to your already busy life.

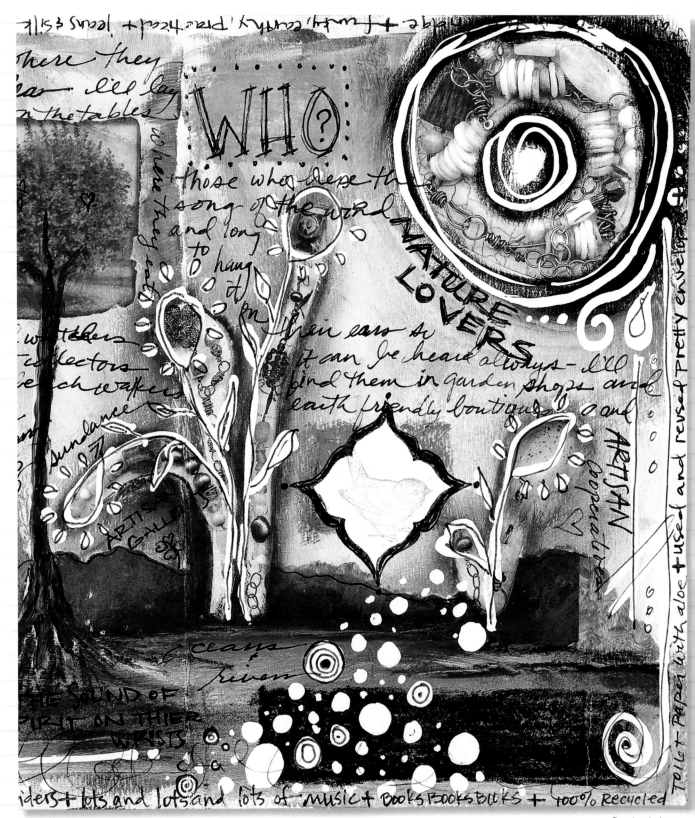

Stephanie Lee

> "The aim of marketing is
> to know and understand
> the customer so well that
> the product or service fits
> him and sells itself."
>
> —**Peter Drucker**

Communicating Value:
The Essentials of Promotion

THE LARGEST CHALLENGE ALL ENTREPRENEURS
face is to successfully promote their product
or service. The biggest mistake most make is
approaching promotion tactically rather than
strategically. Taking the time to think through
a promotion strategy takes the guesswork out
of crucial decisions. This strategy will help you
define your target audience and how to best
reach them through the product name, the pack-
aging design, marketing materials, advertising
copy, and the media you choose for promotion.

It All Starts with Your Customer

Effective promotion communicates the value of your offer in a way your customers quickly and easily understand. The promotion strategy includes

1. Defining your target customer
2. Developing your value proposition
3. Performing a competitive analysis
4. Creating a brand that communicates your value
5. Identifying the promotional tactics appropriate to your business
6. Creating a promotional calendar mapped to specific marketing objectives

Brainstorming in full color helps activate problem-solving resources in our brain's neurology that are not accessed through linear thinking alone.

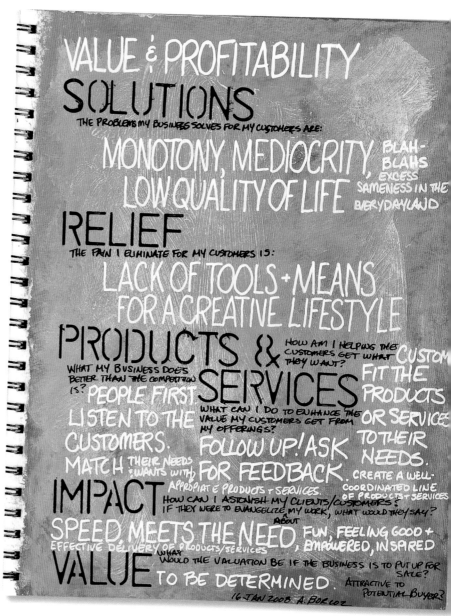

Andrew Borloz

Playing with vintage home design and outdoor magazines, sewing and knitting patterns, and fabrics and notions helped Ellen Rooney identify her target customer.

Ellen Rooney

Beginning with Your Customer to Envision Promotion Materials

I have been working on ideas for a side business designing and making handmade goods with vintage and recycled materials. This exercise helped me refine my idea of who my market might be, which will help me design collateral such as tags, a website, and business cards. The process of searching through magazines and vintage materials for images to represent my customer helped me refine my ideas about who that person is and what sets my potential customer apart.

At first I was just collecting images (of interiors, objects, etc.) that appealed to me, but if I couldn't justify how an image represented my customer,

I had to set it aside. The themes that emerged were handwork, do-it-yourself, vintage, ecology, nature, and humor. My customers are Internet users, but they also spend time thrifting, crafting, and seeking out people with common interests. They tend to use the Internet to build relationships (which often become real-world relationships). They may be explicitly environmentalists, or they may simply value handmade goods and the style of vintage goods and lean toward simplicity and away from consumerism. They like real mail as well as email. And they have a sense of humor and whimsy.

—Ellen Rooney

Defining Your Target Audience

Your target customer is the specific and narrowly defined group of people you aim to serve with your business. This audience is also sometimes called your *niche market*. It's tempting to think that if your audience is huge (women ages eighteen to eighty, or anyone who likes art), that means it will be easier to reach your customer. Actually, the opposite is true. Think of an image of a target. Hitting the bull's-eye of the target means you've hit the mark. It's not a huge area. It is important to narrow your target in a meaningful way so you can easily find and communicate to your intended audience. Otherwise, you will be wasting time, money, and effort unsuccessfully reaching many people who are not interested in what you have to offer. Not only does this waste resources, it also can erode your sense of value and confidence in your offer. In terms of target audience, trying to be all things to all people usually results in not being anything to anyone.

Psychographics are values-based assessments of customers. They describe what brands they buy, how they spend their time, and what work they do. Following are some questions to help you understand the psychographics of your customer.

Demographics describe quantifiable physical, vocational, educational, and geographic attributes including age, sex, race, address, level of education, salary, job title, work status, marital status, and family situation.

JOURNALING PROMPTS

- Where do your customers shop?
- Where don't they shop?
- What media do they consume? List specific magazines, books, blogs, news outlets, TV shows.
- How do they use the Internet? Surf? User groups? Shop? Blog? Sell? Share photos? Attend webinars? Create/download podcasts, movies, stories?
- What trade associations do they belong to? What trade shows do they attend?
- What experts do they follow? Where do they look for advice?
- How do they learn about and shop for products like yours?
- What competitor products do they use?
- What are the demographics of your target audience?
- What demographic trends may affect your business?

Customer Persona Collage

A picture is worth a thousand words, and identifying your customer is worth thousands of dollars. A customer persona helps you visualize your ideal customer.

1. Get a bunch of magazines, catalogs, junk mail, and ephemera and look for images that show your ideal customer. Who is this person? Get specific. Create a journal page or spread that portrays everything you can think of about your ideal customer.

2. Add details that describe what your target customer values most.

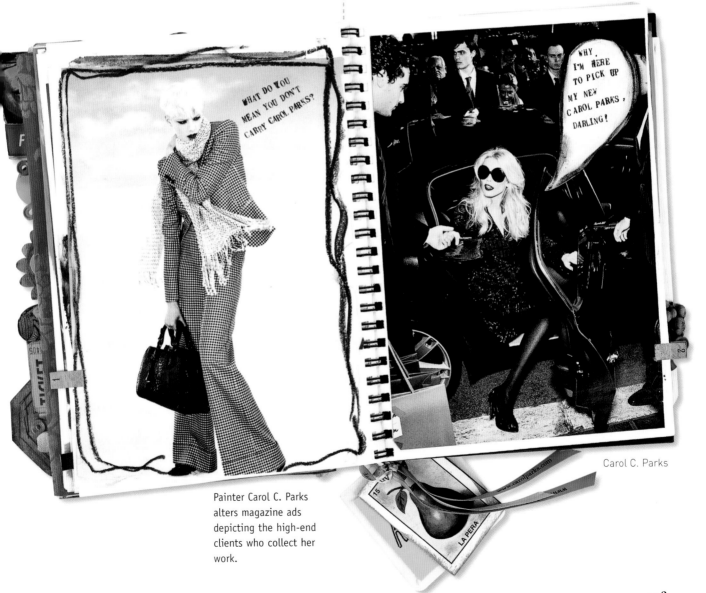

Painter Carol C. Parks alters magazine ads depicting the high-end clients who collect her work.

Carol C. Parks

Competitive Analysis

Performing a competitive analysis from a promotion standpoint helps you gain insight into the value proposition of your competitors.

Do an online search of a few of your main competitors. Survey their websites and any collateral they may publish and answer these questions:

- Who is their target audience?
- Where are they promoting themselves?
- What promotional tactics do they use?
- What is the value proposition they are communicating?
- How effective is the message?
- How are you different from them?

Market Research Sources

Hard data and facts about customers can be found through market research and demographic information such as the census. Market research is either primary (you do the research yourself through tools such as surveys) or secondary (data that has been collected and analyzed by another party). Marketing strategist Jon Ragatz has compiled a comprehensive list of market research resources, available on the Creative Entrepreneur website: **www.TheCreativeEntrepreneur.biz**

Develop Your Value Proposition

An effective value proposition answers the questions your target audience is wondering every time they hear about a new product: "So what?" and "What's in it for me?"

Pitfalls to Avoid in Promotions

- Talking only about the company, instead of addressing the needs of the customer
- Generic promises such as "attentive service with a personal touch"
- Touting features of the product rather than its benefits

Ineffective marketing focuses on the company or the product. When the message is solely about how great the company is, we tend to either tune out or put up a mental barrier against these messages, in the form of skeptical questioning. Effective promotion requires an awareness of and relentless focus on what the customer needs and wants. This is somewhat counterintuitive at first. We think we should be telling people how great we are and how we are better than the competition. But these are the questions customers really want to know and might be too polite to ask: "So what?" and "What's in it for me?"

While you might know the answers to the following questions based on experience, this is an area where research is vital to understanding exactly what your customers need and value most. Once your customers understand that you get their problems, they are open to hearing how your business solves them better than your competition.

CUSTOMER NEEDS

- What are your customers challenged by?

- What does your customer need most?

- What are you customers most concerned about? What do they fear most?

- What are their top challenges or ongoing sources of inconvenience, disturbance, or trouble?

- What are the main problems your product solves for your customers?

- What competing products do they use?

- What are the demographics of your target audience?

- What demographic trends may affect your business?

Features Versus Benefits

Customers buy solutions to their problems, but it's tempting to try to explain all of the features that make your product great. So do this work in your journal, not with your customer:

1. Brainstorm a list of your product features.

2. Next to each feature, describe the benefit of those features. Make sure to highlight benefits in promotional materials.

3. List the problem or problems your product solves. What sort of thing is a hassle or issue for your audience? They know your product is a perfect match for them because…

Remember, your promotional strategy answers these questions: What is the niche your product belongs in? Who are your ideal customers? What makes your products and service unique in the marketplace? How are you different from the competition? How is your business solving a particular problem for the intended audience? The answers to these questions form the basis of your value proposition.

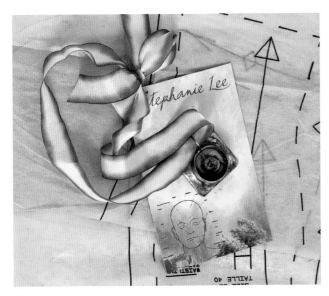

Stephanie Lee

An example of how jewelry designer Stephanie Lee coordinates her packaging and branding to reflect the nature-inspired color palette of her designs.

Branding Basics

A brand can be thought of as a personality for your business. Strong brand attributes quickly convey what your company stands for, make you instantly recognizable and memorable, and help you stand out from the competition. Everything from the company and product names to the logo styling, packaging, and look and feel of your promotional materials should be considered with your brand image in mind.

TIP

When showing your branding and promotion ideas for feedback, be sure to inform the viewer of the objective, the target audience, and other relevant information, and then ask for specific feedback— otherwise people will react with "I like it" or "I don't like it." This subjective feedback is not particularly useful. Ask for the type of feedback you want.

Step Back and Think About Your Brand Objectively

What are the values, qualities, and personality you want your brand to project? Does the name, typography, color scheme, design, and image portray those qualities? The choices should resonate with your target, so be sure to test them out there. It doesn't matter what your best friend, mother-in-law, neighbor, or husband thinks (unless they happen to be your target).

What do you want customers to think when they see or hear about your product? Prospects form opinions and conclusions about your business based not just on how the product looks and performs but how it is packaged. Branding messages are conveyed not only through the choice of name and logo design but also throughout all promotional collateral, including brochures, postcards, sales sheets, business cards, stationary, packaging, signage, website, emails, and blogs.

Qualities of Effective Branding

- Personality attributes consistent across all media
- Conveys the value proposition to customer
- Naming considerations: short, memorable, easy to spell, describes the business
- Conveys individuality, originality
- Distinctive color palette and typography that is not trendy
- Can be trademarked

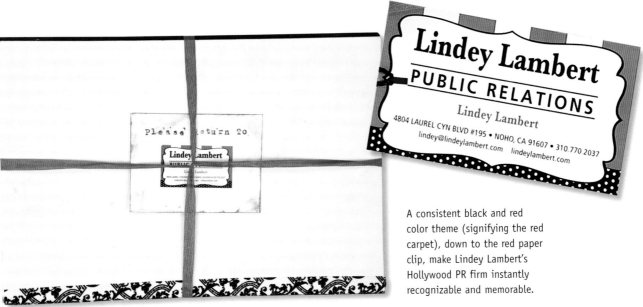

A consistent black and red color theme (signifying the red carpet), down to the red paper clip, make Lindey Lambert's Hollywood PR firm instantly recognizable and memorable.

Lindey Lambert

CASE STUDY:

Pod Post

Pod Post revives the art of the written letter with whimsical mail art wearables, books, zines, and ephemera. The inventors, book arts instructors, and artists Jennie Hinchiff and Carolee Gilligan Wheeler—affectionately known as "the pods"—share a passion for all things bookish, printed, and postal.

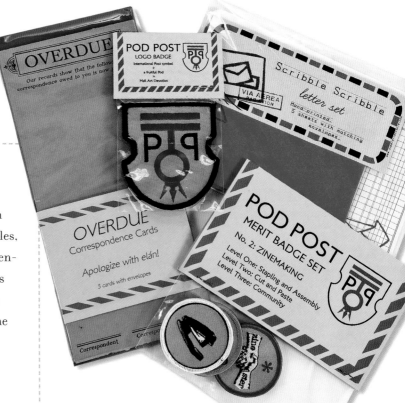

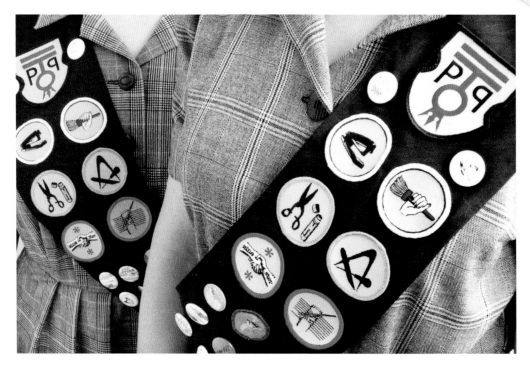

Pod Post's branding extends into their own designed and handmade uniforms. Logo patches are sold and given away with purchase as promotional items. All packaging labels are postage-themed and Pod Post–branded in clear bags to allow the merchandise to show through.

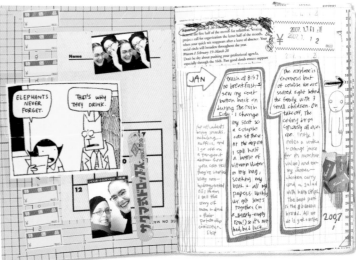

Carolee Gilligan Wheeler

Pod Post Mail Art Bento

Kimagure na Dowa no Hon
(a storybook of whimsy)

Sourcing trips to Japan
for the Pod Post Mail
Art Bento boxes are
chronicled and turned
into promotional zines.

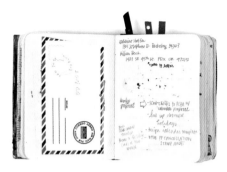 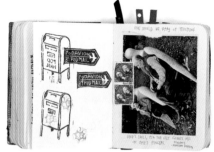 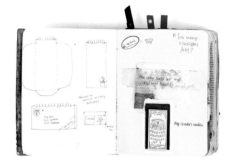

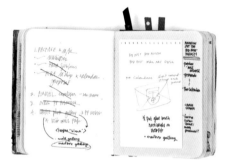 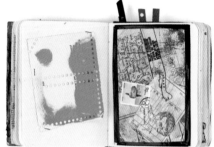 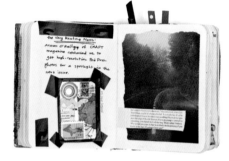

 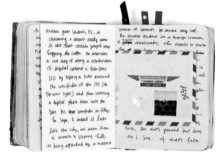 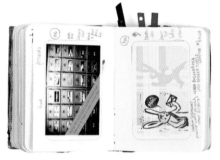

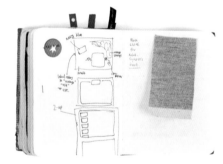 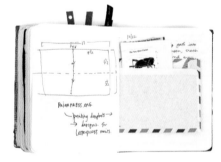 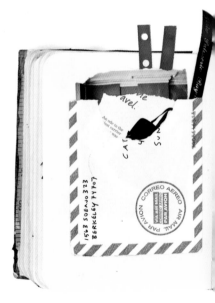

Handmade journals capture branding,
promotion, and product ideas for Pod Post.

Carolee Gilligan Wheeler

Promotional Tactics

Promotion comprises a variety of strategies used to generate awareness, encourage trial ability, generate sales, and expand sales through repeat purchases or referrals. When choosing tactics, consider the following:

Where is your target audience most concentrated? How do they prefer to be reached? Given the time, money, expertise, and personnel available, which tactics will create the most impact with the least investment or risk? Whatever your promotional budget, allocate a percentage for testing out new tactics or refining an existing tactic. Which tactics to choose depends on the outcomes you want and how much it costs to create those outcomes. Some tactics can be done inexpensively or with an investment of time rather than money.

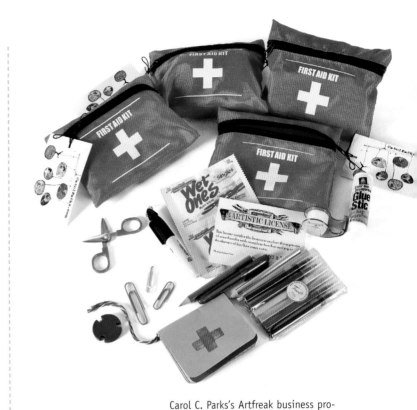

Carol C. Parks's Artfreak business promotes creativity for anyone, anywhere, anytime. The artist's first-aid kit and signature goodie bags are given away as memorable promotional items.

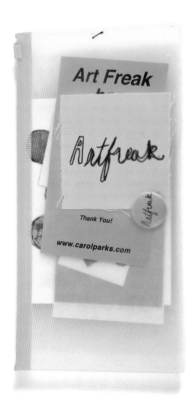

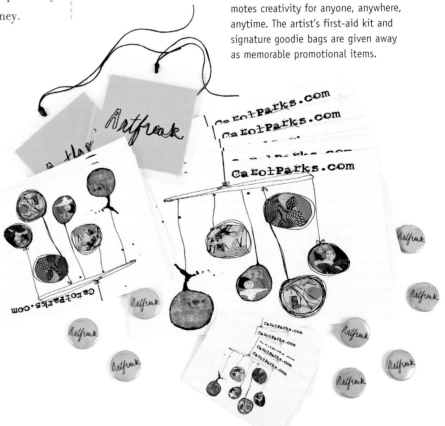

Thinking Outside the Brochure

Most businesses approach marketing with the idea that they need a brochure or website or maybe they should do advertising (because a salesperson from a publication asked them to place an ad). Deciding which tactics to use—and how to do them right—first requires deciding what you want to accomplish (your SMART marketing objective) and how (defined by clear strategies).

The burning question behind all tactical decisions should be: For what purpose? For what purpose do you need a brochure? What strategy does it serve? Thinking through all the tactics that could be used strategically to achieve your objective yields a list of possibilities beyond the brochure. Depending on the nature of your business, a zine or miniportfolio or postcard may be more effective. With the question in mind of what your tactic must accomplish, all sorts of new possibilities open up. If you determine that a brochure is necessary to fulfill a strategic decision, then move forward. All promotional tactics must reflect your brand while speaking primarily to your customer's needs.

Paradoxically, promotion requires enormous creativity to be successful, but promotional materials are not the place to be "artistic." Effective promotion is a problem-solving activity, not an artistic one. As an art director who reviews student portfolios and mentors emerging graphic designers, the biggest mistake I see even design professionals make is that they are trying to be artistic, clever, creative—and, in fact, their work may be just that. But it first must be approached as a problem to solve for the client. In this case, the client is you. Creative entrepreneurs are notorious for rolling up their sleeves and personally doing absolutely everything their business requires. Usually this is because of the real necessity of

Pet photographer Lori Cheung's photos are the focal point for all of her promotional materials. Clients receive branded DVDs of their proofs and email newsletters that are humorous and engaging. At networking events, business cards are displayed in a branded dog dish. Lori keeps all of her promotional ideas in her journal, a repurposed photo album.

not spending cash they don't have. If your promotional efforts are not getting the results you want, consider hiring a communications design professional. Research the candidate or firm to see how they approach problem solving. The improved results of professional promotion will more than compensate for the initial cost. Also consider trading services with a designer. Photographer Lori Cheung trades portrait services with a graphic designer to achieve a consistent, professional look in all of her communications. Because Lori's work is heavily referral based, the DVD clients receive of their photos not only serves a utilitarian purpose but also provides a constant reminder of who did the shoot, with contact information front and center.

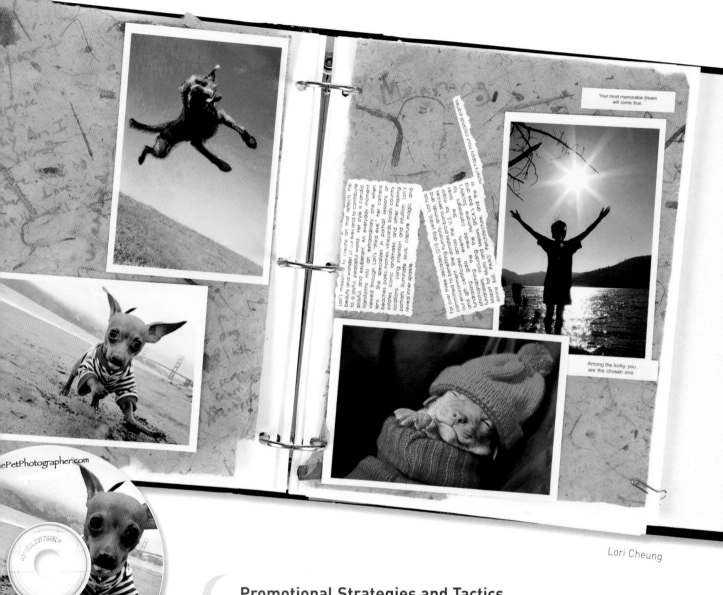

Lori Cheung

Promotional Strategies and Tactics

- Advertising: in print publications or online

- Direct marketing: telemarketing, QVC, infomercials, mailings, catalogs, emails, podcasts, blogs, flyers, giveaways

- Personal selling: trade shows, art fairs, showrooms, distributors/reps, eBay, Etsy, your own online or retail store

- Public relations: pro bono work, linking with causes, event sponsorship, press releases, articles, media mentions

- Sales incentives: coupons, discounts, contests, free trials or samples, point-of-purchase displays

Top Promotion Mistakes

1. Using an email address without your business website name in it. Your email address is an opportunity to reinforce your brand. Never use free email accounts, like Hotmail, for your business email. It's unprofessional.

2. Being too literal when designing a logo.

3. Using trendy typefaces. These not only become dated very quickly, they become trendy because everyone else uses them. Comic Sans and Papyrus are examples to be avoided in promotional pieces.

4. Using too many typefaces on one piece. Typography and color palettes should be thoughtfully considered as part of your brand. Use only one or two that work well together.

5. Talking only about yourself or your company in sales literature, including websites. Remember, clients really want to know how the product or service solves their problem. Let them know you understand their problem and have solutions.

6. Trying to say everything possible about your product on one brochure, sales sheet, or postcard. This guarantees the piece will look cluttered and unfocused and will not serve its intended purpose. Identify one key message your client needs to know and find an original way to communicate that message.

7. Using clip art. Most clip art is cliché, overused, outdated, or just plain ugly, so professional designers typically avoid it. Your piece will be more professional without it.

8. Lack of focal point. Every communications piece, whether printed or online, must present a visual hierarchy of information.

9. Using animated graphics and ads on websites. Unless you are in the motion graphics business, or unless your target audience especially responds to flashing images, any animation on your site is likely to be distracting.

10. Designing a website that is not customer-focused. Visitors must immediately know what's in it for them and exactly how to navigate quickly to the information they are seeking, and "quickly" is about 1 second. Check your web statistics to see how many visitors you have, how quickly they leave, and whether or not they ever go past the home page.

DIY Minijournal and Greeting Card Cover

VISUAL JOURNAL EXERCISE

Minijournals are quick, easy-to-make booklets that are great to add to and easily take out of your journal.

My favorite way to make a minijournal makes practical use of one of my obsessions: collecting beautiful, funky, unique greeting cards, which I use for the covers. Other great materials for minijournal covers include decorative file folders (be sure to incorporate the tabs), cardboard and paperboard (look in your recycling bin and make a cover out of your favorite cereal box), and card stock–weight scrapbook paper, especially the kind printed on both sides.

1. Start with a greeting card you like. Set the envelope aside for now.

2. Open the card and measure the height and width of the open area. Subtract ½" of each dimension to get your paper size. A card that is 10" wide by 6" tall will need paper sized 9½" by 5½".

3. Collect your papers for the inside. Six to ten sheets is a good amount, depending on the thickness of the paper. Any kind of paper is fair game. Consider colored paper, construction paper, graph paper, and notebook paper. Add a few of your prized decorative papers for interest. Trim your pages to the size needed. Save your scraps—these are great for adding to your journal later. I like to save my scraps in the clear plastic sleeve the card is packaged in and then share full packs of scraps with friends who journal.

4. Organize the pages in an order that pleases you, and then fold each page in half. Staple to the card to create a simple pamphlet. If you don't have a long-reach stapler, thread a string through two holes on the spine and tie on the inside or outside.

5. Add the minijournal to your guidebook in several ways:
 - Cut a slit in a journal page, and slide the back cover of your minijournal through.
 - Paste the envelope from the card into your journal. Tuck the minijournal inside.
 - Use paper clips to attach the minijournal to a page.

6. Embellish your minijournal with labels, tabs, stickers, ephemera. The choice of cover itself offers a great title.

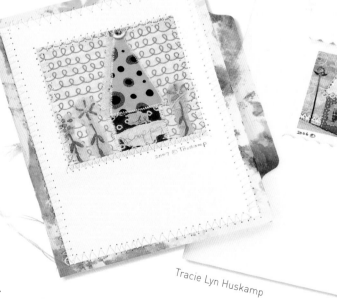

Artist Tracie Lyn Huskamp creates minijournals out of her own greeting card designs.

Tracie Lyn Huskamp

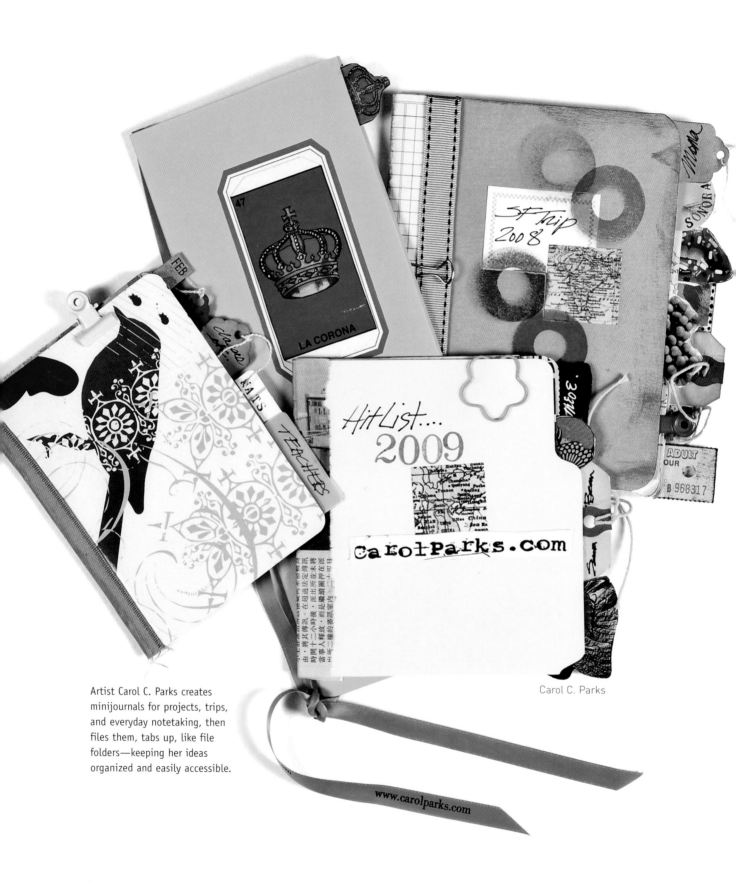

Artist Carol C. Parks creates minijournals for projects, trips, and everyday notetaking, then files them, tabs up, like file folders—keeping her ideas organized and easily accessible.

Carol C. Parks

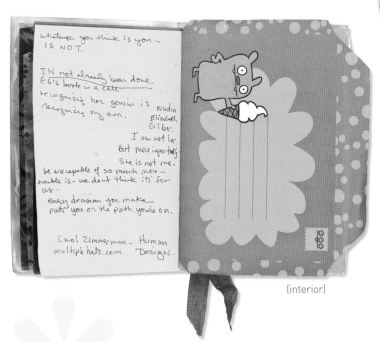

(interior)

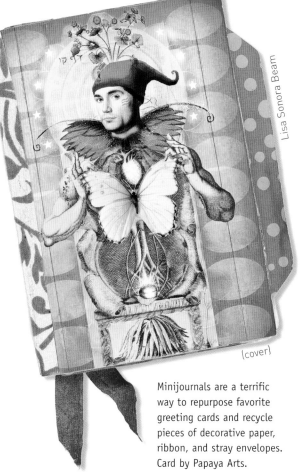

Lisa Sonora Beam

(cover)

Minijournals are a terrific way to repurpose favorite greeting cards and recycle pieces of decorative paper, ribbon, and stray envelopes. Card by Papaya Arts.

Minijournals Are Great for...

1. Overcoming blocks associated with looking at blank white pages. Using a variety of colored paper adds instant visual interest.

2. Documenting your strategic plan. In a minijournal, your plan can easily be accessed. Keep it right on your worktable. Take it with you for review. The more you stay in touch with your plan, the easier it is to stay inspired and on task.

3. Keeping to-do lists and tracking progress on your tactics.

4. Documenting the story behind the story. So much happens internally when you are working on your guidebook processes and exercises! The minijournal is a great place to write about your experience while it's still fresh, so you can then tuck it away for future reference. Because the subconscious mind is activated, we really can get into an altered state when we work.

The insights we're having seem obvious. I call this phenomenon *dreaming on the page*. But just like waking from a dream, it only takes minutes for the vivid aha! to vanish from consciousness. Minijournals help capture insights on the fly.

5. For everyday note-taking. Try creating one minijournal per month. Use them like daybooks and store them in your journal when finished. Review them quarterly and then at the end of the year. You'll see patterns and ideas valuable to you and your business.

6. Recycling. What to do with all the cards you receive? Make minijournals out of this season's stack of holiday or valentine or birthday cards. Write journal entries and add photos in all the blank spaces. These little booklets become powerful reminders of moments in time—without having to create perfect memory pages or even use art supplies.

Conclusion

Happily Ever After

Many people have been inspired by mythologist Joseph Campbell's clarion call to "follow your bliss." I was first introduced to this idea as a young artist and therapist, and I found the prospect both intriguing and daunting. What is bliss, really, and how do you follow it?

Bliss is defined in the dictionary as "supreme happiness." Digging further into Campbell's work, I found this quote: "The way to find out about happiness is to keep your mind on those moments when you feel most happy, when you are really happy—not excited, not just thrilled, but deeply happy. This requires a little bit of self-analysis. What is it that makes you happy? Stay with it, no matter what people tell you. This is what is called following your bliss."

Chapters 1 through 3 of *The Creative Entrepreneur* present tools for self-analysis, from discovering what has heart and meaning and what your innate gifts are, to how you uniquely function mentally, physically, and psychologically. But self-understanding is not that useful unless it is put into practice and used to create something new or transform something old. The ideas, tools, and exercises in this book are meant to be used in an ongoing and as-needed way to help you stay motivated and inspired, and also to support you when your business is not feeling so blissful.

Remember that all creative entrepreneurs are on a hero's journey, and that it is an act of courage to pursue your own passion and purpose in business. Courage comes from the French word for heart, *coeur*. We need courage because pursuing what we love naturally activates fear. Revisit the exercises in Chapter 3 when you are experiencing creative blocks or discouragement. This will help you build a positive and productive relationship with your own creative process so you can do the work your business requires.

Chapters 4 and 5 provide the strategic tools for managing and growing your business. But the value of strategy, or long-term planning, is lost if not monitored,

"When you follow your bliss...doors will open where you would not have thought there would be doors, and where there wouldn't be a door for anyone else."

—Joseph Campbell

measured, evaluated, and recalibrated regularly in the short-term. Learning how to think and plan and act strategically is something that develops over time and with practice. So keep your journal out and use it regularly as a living, growing business plan. Read and reflect on what you have done, and keep adding to it as a place to brainstorm, cultivate new ideas, and measure your progress.

The tools put together here in *The Creative Entrepreneur* are the result of my own searching, through many paths, for how to make my own creative business ideas real.

What makes me supremely happy is not only doing my creative work, but helping others to follow their bliss and prosper in every way doing so.

I wish you all the best in your endeavors and invite you to share your stories of creative entrepreneurship with me at www.TheCreativeEntrepreneur.biz.

—Lisa Sonora Beam

"After attending the Creative Entrepreneur workshop, I came home revved up and ready to make big changes in my life, feeling clear headed and totally focused on possibilities that I had never before imagined. Jettisoning all the dead weight from my work space, committing to a clear set of objectives, and using my newly learned skills set me on the right path to a major expansion of my business!

Using many of the resources suggested in the workshop, I expanded my mailing list by a thousand percent! I took my business from a low simmer to a high boil in less than six months.

The amazing thing about this material is that it helps every part of your life, not just your business. I am now dealing with the natural stumbling blocks life has a way of placing in our paths in all new and creative ways. Everyone should have these tools!"

—Carol C. Parks

Contributors

Lisa Sonora Beam
San Francisco, California, USA
info@TheCreativeEntrepreneur.biz
www.TheCreativeEntrepreneur.biz

Leav Bolender
Earth Imagery
Denver, Colorado, USA
leavbolender@comcast.net

Andrew Borloz
Urban Paper Arts
Westwood, New Jersey, USA
cooknfold@aol.com
www.urbanpaperarts.com
www.urbanpaperarts.blogspot.com

Barbara C. Bourassa
Wren Creative Services
North Andover, Massachusetts, USA
bbourasa@comcast.net

Traci Bunkers
Bonkers Handmade Originals
Lawrence, Kansas, USA
traci@tracibunkers.com
www.tracibunkers.com

Lori Cheung
The Pet Photographer
Albany, California, USA
lori@thePetPhotographer.com
www.thePetPhotgrapher.com

Annie Danberg
Artdance
San Rafael, California, USA
annie@artdance.com
www.artdance.com

Ruth Fiege
Englewood, Colorado, USA
wegerjohn@msn.com

Jennie Hinchcliff
Pod Post
San Francisco, California, USA
mail@podpodpost.com
www.podpodpost.com

Tracie Lyn Huskamp
The Red Door Studio
Wichita, Kansas, USA
www.theRedDoor-
Studio.blogspot.com

Jennifer Joanou
Jennifer Joanou Designs
Pasadena, California, USA
joanoufrank@mac.com

Lindey Lambert
Lindey Lambert Public Relations
North Hollywood, California, USA
www.lindeylambert.com

Stephanie Lee
Stephanie Lee Studios
Rogue River, Oregon, USA
stephanielee@q.com
www.stephanieleestudios.com
www.stephanielee.typepad.com

Pamela J. Lemme
Good Witch Arts
Boulder, Colorado, USA
pamlemme@comcast.net
www.goodwitcharts.mac

LK Ludwig
Zelienople, Pennsylvania, USA
www.gryphonsfeather.typepad.com

Loretta Benedetto Marvel
New Rochelle, New York, USA
artjournal@optonline.net
http://artjournaler.typepad.com/po
megranatesandpaper/

Paule Merlin
San Francisco, California, USA
paule@baladine.com
artblog.baladine.com

Julia Nyman
Mill Valley, California, USA

Carol C. Parks
carolparks.com
North Hollywood, California, USA
cp@carolparks.com
www.carolparks.com

Darcy Ritzau
Darcy Ruth Designs
Santa Barbara, California, USA
www.darcyruthdesigns.com/

Ellen Rooney
Victoria, British Columbia, Canada
ellen@ellenrooneydesign.com
www.ellenrooneydesign.com

Bee Shay
Heart to Hand Studio
Gladwyne, Pennsylvania, USA
bee.shay@hotmail.com
www.beeshay.typepad.com

Lindsey Shelley
Wasilla, Alaska, USA
lindseyshelley@hotmail.com

Carolee Gilligan Wheeler
Pod Post
San Francisco, California, USA
carolee@podpodpost.com
www.superdilettante.com
www.podpodpost.com

About the Illustrations

I'd like to acknowledge all of the people who contributed their journal entries for the book. Every time FedEx arrived with another package, it felt as if a piece of someone's soul was being delivered. It is an enormous act of generosity for these creative entrepreneurs to open up their journals so we can learn from their examples.

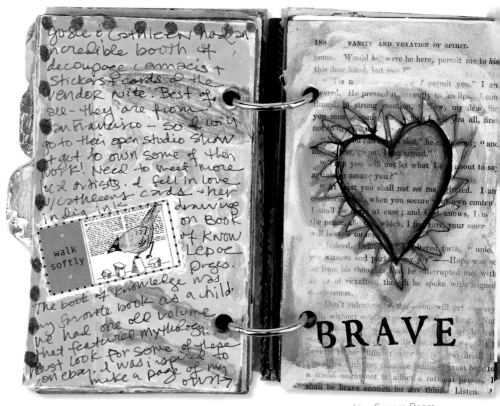

Lisa Sonora Beam

Resources

The Creative Entrepreneur Online

Visit the Creative Entrepreneur website for more resources, including Creative Entrepreneur workshops and to participate in our online community.

The Creative Entrepreneur
www.TheCreativeEntrepreneur.biz

North American Resources

Bonker's Handmade Originals
www.tracibunkers.com
Journaling workshops, alphabet rubber stamp sets, handmade journals, collage ephemera.

Crafts Etc!
www.craftsetc.com
Craft and art supplies

Daniel Smith, Inc.
www.danielsmith.com
Papers and art supplies

Dick Blick Art Materials
www.dickblick.com
Art and craft supplies

Echoes des Voyages
www.echoesdesvoyages.com
International journaling retreats, art supply totes for travel, rubber stamps, ephemera.

Flax
www.flaxart.com
Art and craft supplies

JetPens
www.jetpens.com
Japanese pens, pencils, craft, and office supplies.

Jo-Ann Fabric and Crafts
www.joann.com

Kelly Kilmer
www.kellykilmer.com
Mixed-media workshops and handcrafted journals

Kate's Paperie
www.katespaperie.com
Craft supplies and journals

Michael's
www.michaels.com
Art and craft supplies

Paper Source
www.paper-source.com
Papers, bookmaking supplies, rubber stamps, journals.

Pearl Paint Company
www.pearlpaint.com
Art and craft supplies

International Resources

Bondi Road Art Supplies
Bondi, NSW Australia
www.bondiroadart.com.au
Art and craft supplies

Creative Crafts
Phone: 01962 856266
www.creativecrafts.co.uk
Crafting supplies

Eckersley's Arts, Crafts and Imagination
Stores throughout Australia
www.eckersleys.com.au
Art and craft supplies

Graphigro
Paris, France
www.graphigro.com
Art supplies

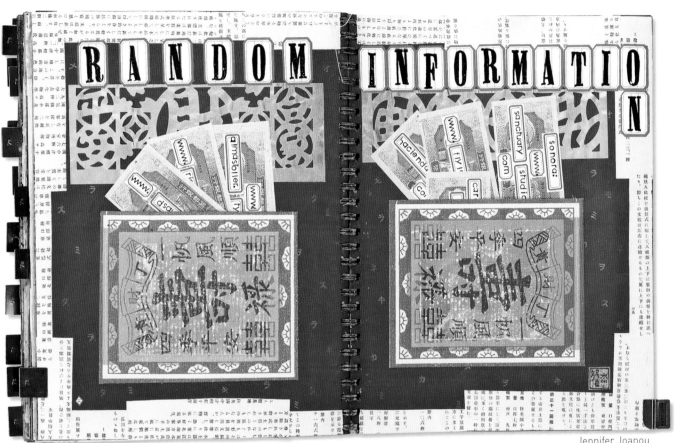

Jennifer Joanou

HobbyCraft
Stores throughout the UK
www.hobbycraft.co.uk
Art and craft supplies

Japanese Paper Place
Toronto, Ontario, Canada
www.japanesepaperplace.com
Japanese washi and decorative
papers

Paper-Ya
Vancouver, British Columbia,
Canada
www.paper-ya.com
Handmade and specialty papers

Wills Quills
Chatswood, NSW, Australia
www.willsquills.com.au
Exotic papers, bookbinding
accessories, journals.

Acknowledgments:
One Million Thank-yous Wouldn't Be Enough

Heartfelt gratitude
to my business mentors:

Jane Lorand, whose vision for transformative business led to the creation of the Green MBA. Jane's work with using the feeling, thinking, and acting modes was one of my biggest takeaways from business school.

Jon (JR) Ragatz, for being a champion of my work ever since he saw my visual journals. He saw the significant opportunities for my work before I did, pointed me in the right direction, and connected me with my first clients. JR also possesses the deft skill of being able to kick people in the ass when needed, yet somehow make it feel like a pat on the back. The biggest compliment, though, is that JR chooses to work with me at Digital Hive when he could be some bigwig marketing VP anywhere in the Fortune 100. Thanks for all you to do make Digital Hive rock, Green Hornet!

John Stayton, for cofounding the revolutionary Green MBA and for asking me the life-changing potent question: What unique gifts can you leverage that have value in the marketplace people will pay for?

Rick Zalon, for being a consummate CPA, tough guy, and skeptic; for encouraging my artistic nature and advising me to create a business I felt passionate about. Accountants do not typically encourage passion, but Rick is no typical CPA. He responds kindly to vexing tax questions like "Is the Kate Spade bag deductible if used for my art supplies?"

And Thanks to My Art Tribe

The following artists are exceptional is so many ways that I am simultaneously awed, inspired, and incredibly grateful to know them. They have maintained an unwavering belief in my artistic and business escapades over the years: Traci Bunkers, Ken Cade, Lori Cheung, Annie Danberg, Lindey Lambert, Kelly Pasholk, Darcy Ritzau, Elizabeth Scherle, and Tammi Sonnen. Their friendship gives me the courage and conviction to press onward in living a life of the imagination. I can't thank Carol (CP) Parks enough for sharing countless acts of artistic generosity not only with me but with many, many emerging artists. David Harris— every writer needs a whip cracker. Juliana Coles originally suggested I teach a workshop on the material that became this book. Kelly Pasholk and Jennifer Mitchell are the busy bees who kept Digital Hive buzzing while I wrote. My mother, Linda, and sisters Jennifer and Lori are effortlessly creative in all they do. They inspire my work. This project was nurtured from seed idea to finished book by my editor, Mary Ann Hall. Her vision and skill exemplify creative entrepreneurship. Many thanks to Mary Ann and the whole team at Rockport/Quarry for your confidence and care in producing this material.

"THERE IS A VITA[L]
AN ENERGY, A QUIC[K]
LATED THROUGH YO[U]
BECAUSE THERE IS O[NE]
TIME, THIS EXPRESSI[ON]
IT, IT WILL NEVER EXIST THRO[UGH]
WILL BE LOST. the wor[ld]
it . YOU MUST KEEP THAT CHANN[EL]
DETERMINE HOW GOOD IT IS
IT COMPARES WITH OTHE[R]
TO KEEP IT YOURS, CLEARL[Y]

Y, A LIFE FORCE,
...NING THAT IS TRANS-
...NTO ACTION; AND
...Y ONE OF YOU IN ALL
... IS UNIQUE. IF YOU BLOCK
...H ANY OTHER MEDIUM AND IT
... WILL not have
...OPEN. IT IS NOT FOR YOU TO
...NOR HOW VALUABLE. NOR HOW
...EXPRESSIONS. it is for you
...AND DIRECTLY."

martha graham

About the Author

Based in the San Francisco Bay area, Lisa Sonora Beam is a business and marketing strategist, writer, and visual artist. She consults with corporations and conducts seminars on creativity and business internationally. *The Creative Entrepreneur* is based on the workshops she designed especially for individuals who want to turn their passions into viable business opportunities.

In 2003, she founded Digital Hive EcoLogical Design, the first marketing communications firm to specialize in promoting green initiatives. She has developed and taught courses in Green and Social Marketing for Dominican University's Green MBA program.

She has a Bachelor of Music in Music Therapy from DePaul University in Chicago, and an MBA in Sustainable Enterprise from New College of California. www.TheCreativeEntrepreneur.biz